The Dieppe Connection

The Town and its Artists from Turner to Braque

Published to accompany the exhibition
'Rendez-vous à Dieppe'

Brighton Museum and Art Gallery
1 May–30 June 1992

Sponsored by **SEALINK** **NEWHAVEN–DIEPPE**

The Herbert Press in association with
The Royal Pavilion, Art Gallery and
Museums, Brighton

Copyright © 1992 The Herbert Press Limited
and The Royal Pavilion, Art Gallery and Museums, Brighton
Copyright in the text © 1992 by the individual authors
Copyright under the Berne Convention

First published in Great Britain 1992
by The Herbert Press Ltd, 46 Northchurch Road, London N I 4EJ
in association with The Royal Pavilion, Art Gallery and Museums, Brighton

Edited by Caroline Collier (RPAG & M) and
Julia MacKenzie (Herbert Press)
Designed by Pauline Harrison

Set in Poliphilus
Printed and bound in Great Britain by
BAS Printers Limited, Over Wallop, Hants.

A CIP catalogue record for this book is available
from the British Library

ISBN 1-871569-48-6

BRIGHTON
BOROUGH COUNCIL

Exhibition organized by Caroline Collier,
assisted by Susan Fasquelle, Jane Glennon and Tom McGill
Part of the Brighton International Festival

Front Cover: *Harbour Scene, Dieppe* (detail) 1885,
by Paul Gauguin, Manchester City Art Galleries

Back Cover: *Bocque* 1932, by Ben Nicholson,
Arts Council Collection, The South Bank Centre, London.
Reproduced by permission of Angela Verren-Taunt

Contents

Preface

The close connection between Brighton and Dieppe dates back to the early nineteenth century when both towns became fashionable as resorts under Royal patronage. Today the historical link between the towns forms the basis for an active programme of cultural and economic exchange. This exhibition is the result of research by a number of people over many years. It was originally proposed by Philip Vainker, then Keeper of Art at Brighton Museum and Art Gallery, as an examination of the role of the anglophile painter Jacques-Emile Blanche, a disseminator of ideas and influences throughout the Edwardian era and a frequenter of Dieppe, Brighton, Paris and London. Blanche's house in Dieppe was a meeting place for artists and writers from both sides of the Channel, including Beardsley, Conder, Degas, Gide, George Moore, Monet, Pissarro, Sickert and Whistler.

The historian and writer, John Willett, had been planning for several years a wider-ranging exhibition about French and British artists and writers in Dieppe. This was to begin with Bonington and Turner and include artists working there in the 1920s and 1930s, among them Lotiron, Hodé, Matthew Smith, Christopher Wood, Ben Nicholson, Braque and Miró. We had decided to expand the scope of our exhibition and early in 1991 John Willett and the art historian Sophie Bowness were invited to work with us.

Almost midway between London and Paris, Dieppe is important to the history of art and literature for its appeal as a subject (with its Casino, harbour, seaside, compelling architecture, dramatic coastline and skies, and accessible countryside). It was however the particular mixture of fashionable resort and working port, and the stimulating café society, which made Dieppe at the turn of the century the chief summer resort for the more urbane French and British artists, writers and intellectuals. Later, Dieppe and Varengeville were the setting for an important relationship between Ben Nicholson and Braque, at a time when British artists were beginning to establish themselves within the European avant-garde. The exhibition explores the effect of Dieppe and its atmosphere on British and French artists, focusing on the exchange of influences between two cultures.

We are very grateful to John Willett for the breadth of knowledge, enthusiasm and commitment that he has brought to the project, and to Sophie Bowness for all her careful research. They have both formed the exhibition and contributed to this publication. We would also like to thank Anna Gruetzner Robins for her essay about visual and literary connections in *fin de siècle* Dieppe, and Etienne Lymbery, who compiled the chronology, with additions from the other contributors and from Michael Barker, who also supplied the bibliography.

The exhibition would not have taken place without the most generous sponsorship of Sealink Newhaven – Dieppe. Given the strong links between the history of the Newhaven – Dieppe line and the subject of the exhibition, we are especially pleased to have been able to collaborate closely with Sealink and are indebted to Bill Laidlaw, Director, and his assistant Lynn Marlow for their imaginative support. We also wish to acknowledge that this publication has been awarded a grant by the Paul Mellon Centre for Studies in British Art. We would like to thank the Museums & Galleries Commission for arranging indemnity cover. We are, of course, most grateful to Pierre Bazin, Curator of the Château-Musée de Dieppe, and to all the lenders, who have responded so generously to our requests.

RICHARD MARKS, *Director*
The Royal Pavilion, Art Gallery and Museums,
Arts and Leisure Services

Sponsor's Foreword

Sealink Newhaven–Dieppe is delighted to be associated with the first exhibition to be devoted to Dieppe as a meeting place for French and British artists and writers. The cross-Channel connection between Sussex and Normandy is integral to the history of the artistic exchange between Britain and France.

Most of the British artists represented in this exhibition arrived in Dieppe from London by way of Brighton or Newhaven. That intrepid early artist traveller, Cotman, arrived in Dieppe in 1817 after a 42-hour crossing from Brighton. By 1824 the journey had become easier and the first steam crossing from the Chain Pier was made by the *Rapid* on 15 May of that year. In 1825 the wooden paddle-steamers the *Eclipse* and the *Talbot* sailed from Newhaven. Although Shoreham and Brighton continued to be used by travellers to Dieppe, by the mid nineteenth century Newhaven was the British point of exit and entry to and from Dieppe. At this time, with the establishment of the railway line from Paris to Dieppe and from London via Lewes to Newhaven, France and Britain made formal agreements to run a joint service.

We hope that sponsorship of this exhibition will enable us to create an even stronger link with Dieppe, Upper Normandy and the whole of France, and help continue the European awareness that is certainly prevalent in the southeast of England. This is particularly apt during 1992. Our support of the exhibition helps to encourage the arts in the southeast, by bringing to Brighton an important show of paintings and drawings created in and around Dieppe. We also feel that the exhibition will encourage people to visit the charming town of Dieppe and the surrounding area, so continuing the long-standing relationship between the southeast of England and Upper Normandy.

BILL LAIDLAW, *Director*
Sealink Newhaven–Dieppe

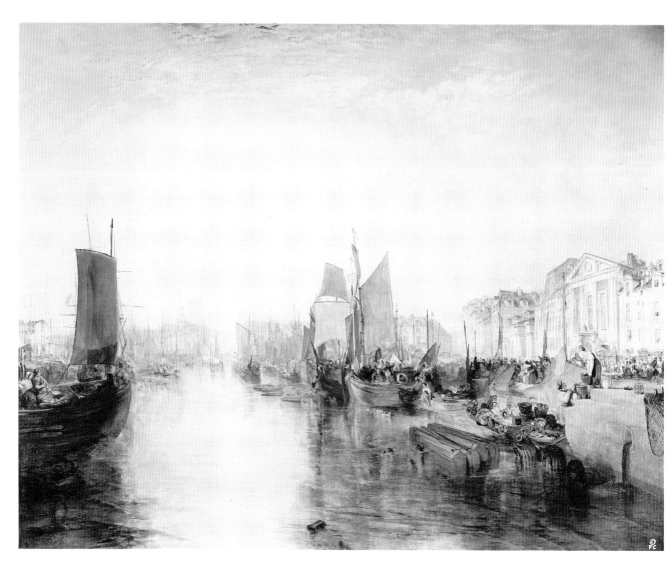

J.M.W. TURNER
Dieppe Harbour 1825
oil on canvas, 173.7 × 225.4 cm
Courtesy of The Frick Collection, New York

Rendez-vous à Dieppe

John Willett

HAS ANYONE ANYWHERE TRIED TO *show* the role of Dieppe as a meeting-point in the arts? Strange if not. For during one and three-quarter centuries of peaceful relations between England and France since our last serious fight, a fruitful traffic developed across the Channel, carrying ideas, influences and individual art lovers or practitioners from one capital to the other. Much of this traffic has been funnelled through the small Norman port where so many different artists have found common interests in the beaches, the buildings and the special quality of the light. Here is the place, not quite midway along a straight line between London and Paris, where the evidence of great transformations in painting, literature, music and the theatre can be seen against a single background. There is a shared beauty and a shared liveliness, yet the individual contributions stand out. Turner, Delacroix, the leading Impressionists, Whistler, Sickert and on to Braque; Flaubert, the Dumas, George Moore, Wilde and Maeterlinck; Saint-Saëns, Fauré, Debussy, Roussel – these are just some of the major figures who stopped off or passed through between 1815 and 1939. We are looking at the period between the end of one great European war and the beginning of a greater. What we see could be a microcosm of the modern age.

If there has been any real exploration of this story it has concentrated on two central personalities: Walter Richard Sickert and Jacques-Emile Blanche. Those two artists lived roughly in the same years, from the 1860s to the middle of World War II, and they spent them largely in Dieppe, returning in the winter months respectively to London and Paris but each also having a footing in the other capital. They knew and liked one another, swapped pictures and exchanged artistic advice and personal confidences. Twice at least in the past twenty years they have been the subject of joint exhibitions which showed the compatibility of two very different men, Blanche the *mondain* son of a great French alienist, Sickert the bohemian and occasional thespian, son of a German artist from Schleswig-Holstein and his English wife. Both painted in Brighton as well as Dieppe, each did some of his finest work by the sea. But convincing though the two shows were as evidence of a shared sense of place and a common circle of friends, they represented only the nucleus of a much wider artistic community, which can now be reconstructed around them, starting before and finishing after the Blanche-Sickert heyday of 1880 to 1910. It was conspicuously a community of French and British artists, who often tackled the same subjects. At the same time it was extending into the musical, literary, journalistic and social worlds.

The story of our cross-Channel relations begins regally enough with the restoration of the French monarchy in 1815 and the development of Brighton under the stimulus of the Prince Regent. This large and active town, with its Royal Pavilion, was the model for the evolution of Dieppe as a watering-place, and the earliest Channel crossings by sail and paddle steamer were made from Brighthelmstone – or in the 1830s briefly from Shoreham-by-Sea – to the much more compact Dieppe with its old seaward fortifications and the river Arques snaking randomly along the flinty beach. On the French side the impetus came from the 26-year-old Caroline, Duchesse de Berry, south Italian wife of the heir to France's Charles X, who decided to create a centre for sea-bathing of a more or less aristocratic kind, generally under medical supervision and never (of course) within two hours of a meal. It was she who sponsored the construction of the bathing huts of the Bains Caroline at the west end of the front – the forerunner of the municipal Casino – along with the Bains Chauds some two or three hundred yards into the town, the elegant small theatre – now disused – and other modern conveniences for the better-off.

This was the start of a new cosmopolitanism, when Madame Récamier took her summer Salon to Dieppe and the émigré Spanish banker Marquis d'Aguado brought Rossini to participate in ceremonies and pageants in honour of the Duchess. The stock of the British stood high then; the first Anglican chaplain was appointed in 1825; the game of badminton was introduced; while among the Duchess's benefactions to the town was a gift of seventy-six volumes of Sir Walter Scott. Already in 1814 David Wilkie and Benjamin Robert Haydon came over on a short trip, much as Ardizzone and Barnett Freedman would do after 1945. Hazlitt crossed from Brighton in 1824 to make notes for a travel book; he stayed at Pratt's Prince Regent Hotel, where passers-by serenaded him with

'God Save the King'. Other artists toured more extensively across Normandy, notably Cotman, Bonington, and David Roberts. Turner had made his first trip by 1825, when the Royal Academy showed his big view of the harbour that is now in the Frick Collection in New York. Of the French artists, Corot stopped in Dieppe, but has not left much trace. The younger Isabey was just becoming known. The whole phase lasted some fifteen years, till Charles X was overthrown in Paris in 1830. His daughter-in-law had prudently moved to Scotland in 1829, only to be arrested for conspiracy on her return in 1832.

Dieppe was (and still is) a relatively small town, none too closely linked with the mysterious inhabitants of Le Pollet, baggy-trousered fishermen thought to be of Greek or Genoese origin, who lived across the river and beyond the shipyards. The fall of the Bourbons found Dieppe already poised to grow into a busy and entertaining summer resort, with an annual season for visitors: the Bérigny dock was dug out near its centre; there was a new Le Pollet bridge; while 1830 saw the building of the large Hôtel Royal which figures later in Sickert's paintings and would house some of the grander arrivals, a good few of them English. Two years later Liszt was staying at Ecorcheboeuf outside Dieppe, and gave a charity recital in the town. Under Louis Philippe of Orléans, the new constitutional monarch whom Daumier portrayed as a dumpy pear, the royal presence was less evident, though hardly remote, since the Orléans family château was at Eu, the abbey town of Saint Laurence O'Toole, about twenty-five miles up the coast. It was here that the young Queen Victoria twice visited the king in the early 1840s; she can be seen in a lovely little Isabey painting in the Dieppe museum, being towed ashore through the breakers in a bathing machine. And if there no longer seems to have been quite the same curiosity about this part of France among the British artists as in the 1820s, Thackeray could report the reverse happening as the French began feeling the impact of landscape painters such as Constable and Turner. In 1837 it still took twenty-four hours to travel between the two capitals via Dieppe-Brighton. But pressure for a Paris-Dieppe railway had begun, with Aguado as one of the would-be financiers.

The great change came in 1848, when the constitutional monarchy was blown away by the revived spirit of revolution, to be replaced briefly by a second republic under the presidency of Louis Napoleon, nephew of the late emperor. For a while this was influenced by the freemasons, and by the liberal protestants of certain centres like Dieppe. But what most affected the situation of the town at this point, and the whole relationship between British and French artists, was not so much the political events as the opening of the new railway line from Rouen to Dieppe, linking with the earlier through line from Paris to Le Havre. Like so many other railways outside England these were the work of British engineers – Joseph Locke for the main line, and his colleague Newman for the Rouen-Dieppe branch – with gangs of navvies organized by the great contractor Thomas Brassey; and they led on the English side to the development of Newhaven, east of Brighton, as the port for the London trains. From this point on, and right through the Second Empire which followed, there was a complete change in communications, opening up the provinces to artists from Paris, and putting Dieppe in particular on the most direct route between the two capitals.

It was now that the republicans Millet and Courbet became the most powerful influences in French painting, with the Pre-Raphaelites as their tamer English counterpart. The new mobility allowed the Realism of the first two to affect the Belgian and German painters who came to Paris, while the English group were formative in the birth of Symbolism on the continent some two decades later. Ruskin himself went to Dieppe as soon as the railway was open, but passed straight through; in the 1860s he wrote an introduction to Ernest Chesneau's presentation of the English painters, but never showed himself interested in the new developments in France. These were important however, for people like Sickert's father, whose friend Scholderer was within Courbet's orbit in Paris, and for the mixed group of artists who studied there with Lecoq de Boisbaudran: Whistler, Edwin Edwards, Fantin-Latour, Scholderer himself and the future head of the Slade, Legros. Through their new connections such travellers could now go beyond Ruskin's insular approach to the modern painters, and discover what could be learnt by direct contact. Dieppe was not yet a really mixed community such as developed later, and Delacroix, who spent several summers at the Hôtel de Londres in the 1850s absorbing and painting the seascape, seems not to have had all that much contact with the English. Yet this was when the town was getting a growing reputation as a fashionable and amusing centre: as the critic Jules Janin wrote,

the well brought-up man knows Dieppe as well as he knows the Chaussée d'Antin. He is as familiar with Le Pollet as with the Tuileries Gardens. He could get from Varengeville to Poissy with his eyes shut.

The Emperor and his wife Eugénie visited Dieppe, studied Henri IV's battlefield at Arques, granted the town a state tobacco factory, replanned the promenade and stimulated the refurbishment of the theatre. In 1857 a more modern casino

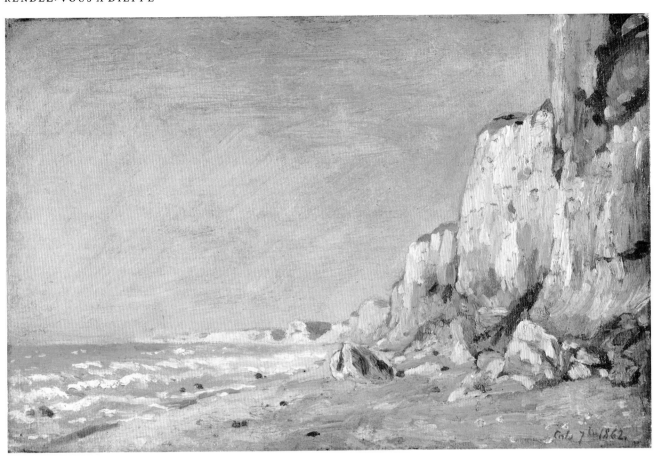

Félix CALS
14. *Cliffs near Dieppe (Falaises près Dieppe)* 1862
oil on canvas, 20.7 × 31.7 cm
The Syndics of the Fitzwilliam Museum, Cambridge
Reproduced by permission of the Fitzwilliam Museum,
University of Cambridge

was built in the style of the Crystal Palace and the English press were invited over for the opening, led by the editor of Bradshaw's railway guide; 'henceforth', wrote *Punch*'s reporter, 'England numbers one watering-place more'. In 1866, when Dieppe had a professional casino orchestra of thirty-eight players with a repertoire including extracts from *Tannhäuser*, the port was the fifth busiest in France, ranking ahead of Rouen. It was then that Chesneau's book on the English artists appeared, and at the second Exposition Univer-selle in Paris in 1867 these were for once well represented; though on other occasions the French press more than once remarked on their absence.

The war against Prussia which the Emperor launched in 1870 had mixed results. It led to the fall of the imperial couple, who fled to England (Eugénie taking the Dieppe route); to the unification of Germany in a new Reich under Wilhelm I of Prussia; to the proclamation and bloody suppression of the Paris Commune; and in due course to the Third Republic which remained the embodiment of France until World War II. For Dieppe it meant occupation by the Prussian Army until the middle of 1871, and the payment of a million-franc fine. But in the arts its results were more positive. For a number of the new artists who had been rejected from the imperial Salons before the war, and figured in the Salon des Refusés which the Emperor instituted in 1868, took refuge in London. Here they were brought together not only with a different ambience, among the mists and fogs of the Thames, but also with other artists, and with the principal dealer of the Barbizon School (in particular Millet) who had built up a British clien-tèle among collectors like the Ionides family, the Paisley mill-owners and the Earl of Carlisle, and now introduced them

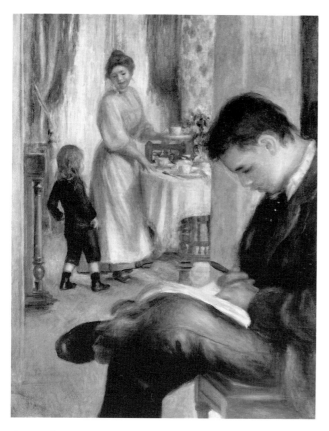

Auguste RENOIR
Breakfast at Berneval 1898
oil on canvas, 81.25 × 66 cm
Private Collection
Reproduced courtesy of Christie's

and Varengeville-sur-Mer, to name only those which figure most in the paintings. There was a nucleus around the Casino, where the cliffs begin beyond the fifteenth-century Château; here were the now demolished villas of the Halévy family whose father had taught Bizet, Gounod and Saint-Saëns; of the great Paris alienist Dr Blanche with his painter son, and of Blanche de Caracciolo, a Neapolitan duchess who led a slightly mysterious life featuring visits from Prince Poniatowski and the Prince of Wales. But there were also new figures elsewhere: the Bérards at Wargemont to the north, who were Renoir's chief patrons during the rise of Impressionism; the great Lord Salisbury at Puys, where the younger Dumas had already settled; the Countess Greffulhe at Caude-Côte on the cliffs behind the Château, who became a devoted patron of Fauré and in 1893 would sponsor the first Paris production of *Tristan und Isolde*. With hosts like these to entertain them, a succession of gifted artists descended on the Dieppe area and got to know one another in the cafés and the Casino, painting the classic Dieppe scenes or exploring the Arques ruins and the lovely forests and valleys nearby.

There were summers of great activity, starting in 1882 when Durand-Ruel took a house on the 'Côte de Rouen' and conferred there with Monet and other artists on how to relaunch the Impressionists after the initial boom in their pictures had subsided. Degas and Gauguin arrived in 1885 for relatively short visits; Whistler first stayed with the Sickerts at that time, while Jacques-Emile Blanche was at the Bas-Fort Blanc nearby; this must have been when Sickert told Gauguin that he should have remained a bank clerk — a famous misjudgement. In 1895 the English started arriving in earnest: Dowson, Conder, Beardsley, Arthur Symons, while Lutyens's great house at Varengeville, 'Le Bois des Moutiers', was being built, and Oscar Wilde in Berneval was trying to recover from his experiences in Reading gaol; once arrived, he met with notable sympathy from William Rothenstein, the Norwegian artist Frits Thaulow and André Gide.

This, however, was when the Impressionist exhibitions were over, and although Camille Pissarro made some fifty paintings in his annual visits to Dieppe during the first three years of the new century, they reflect the new, more luminous Post-Impressionism of Seurat, with its delicately anarchist aura. A certain synaesthesia was by then in the air, a blurring of the borders between the arts, as Symbolism became more influential. Here we should notice the presence, most summers from 1892 on, of the Belgian poet Maurice Maeterlinck, first near Luneray some twelve miles southwest of Dieppe, and then at the abbey of Saint Wandrille further south. Socially, Maeterlinck wished to remain private, it seems, but his *Pelléas*

to Monet, Renoir and other innovators. This was Paul Durand-Ruel, who took on some of the future Impressionists whom the elder Daubigny had brought to see him in London, and he continued to handle them after their return to France. There were also others who did not return, like the Communard sculptor Jules Dalou and Courbet's follower Legros. The result was to reactivate artistic exchanges and induce British artists to send to 'the Paris Salon', which now diversified into the Nationale, the Artistes Français, and subsequently other large groups.

It was in this new climate that the most productive phase of Dieppe art and music now began. Particularly in the summer season the villas and lodgings filled up with the intellectual middle-class, along with a number of wealthy patrons, spilling out over the nearby coastal villages: Berneval, Puys, Pourville

et Mélisande was a key work of the period, inspiring not only Debussy (as did Rossetti's *The Blessed Damozel* a few years earlier) but also Fauré, who wrote the incidental music for the play's London production.

These two were extraordinarily original composers, and each of them visited Dieppe more than once. Indeed music now seemed to take a more important place in the story, with Pierre Monteux conducting the Dieppe Casino orchestra in its splendid new Mauresque building until the outbreak of war in 1914. Admittedly the Swiss, Félix Vallotton, an artist of the Nabis group, worked at Varengeville in 1903 and 1904, but Monet and Renoir scarcely painted in the region now, and even Blanche devoted himself more often to portraits, whether of his contemporaries in the arts (where he left an impressive record, now largely in the Rouen museum) or of chic sitters who might equally well have gone to Helleu, Sargent or Boldini. In 1904 he acquired a studio in London, where he had many fashionable friends. Sickert too was less often in

Camille PISSARRO
54. *The Church of Saint Jacques in Dieppe (L'Eglise Saint Jacques à Dieppe)*
1901
oil on canvas, 54.5 × 65.5 cm
Paris, Musée d'Orsay. © Photo R.M.N.

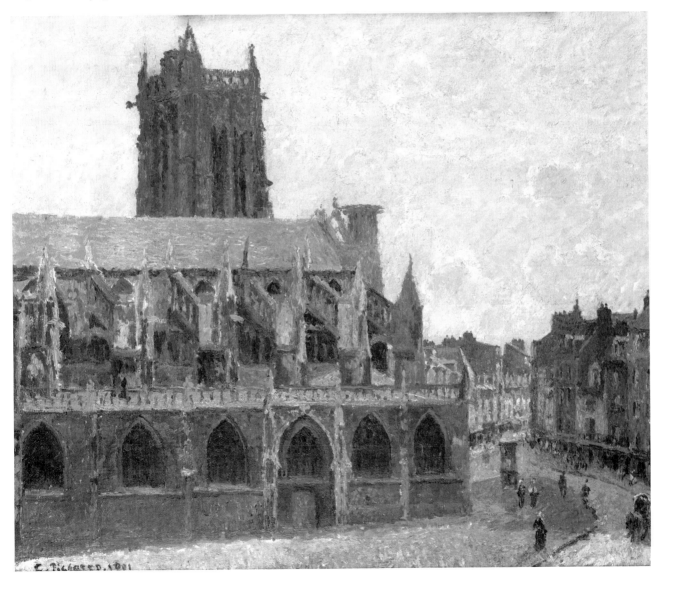

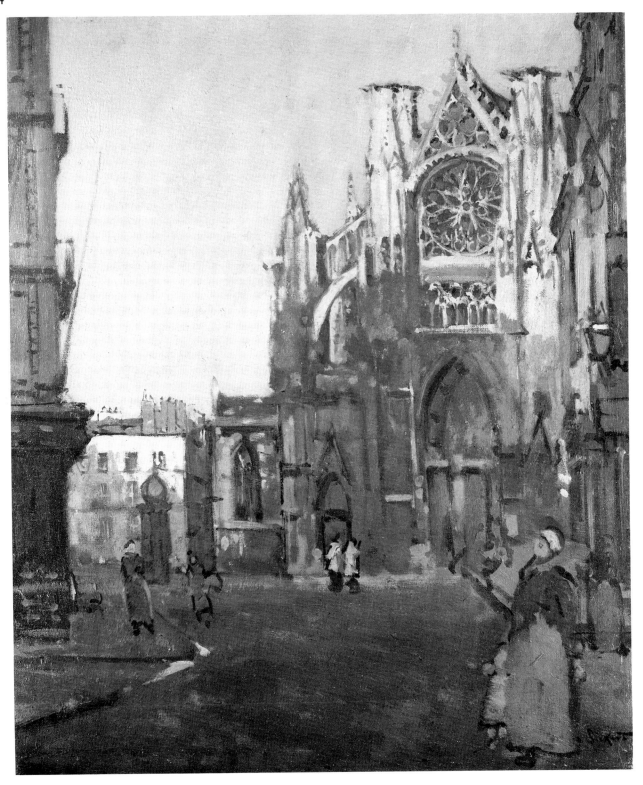

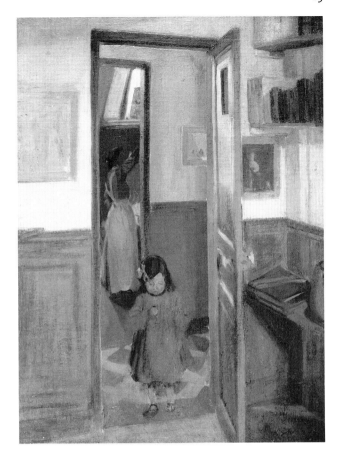

Harold GILMAN
25. *In Sickert's House, Neuville c.* 1907
oil on canvas, 59.7 × 54.7 cm
Leeds City Art Galleries
Reproduced by permission of the Courtauld Institute of Art

OPPOSITE
Walter Richard SICKERT
72. *Saint Jacques Façade c.* 1899–1900
oil on canvas, 55.9 × 48.2 cm
Whitworth Art Gallery, University of Manchester

LEFT
Walter Richard SICKERT
76. *The Inner Harbour (La Darse) c.* 1902
oil on canvas, 151.2 × 53.4 cm
Private Collection
Photograph courtesy Browse & Darby Ltd

Dieppe from then on, and when his younger colleagues from Camden Town crossed the Channel to paint Dieppe subjects they could sometimes occupy his Neuville house the other side of the harbour.

Now the traffic involved William Nicholson and Matthew Smith, and the visiting artists – including amateurs like Sir William Eden whose son Anthony was born at Varengeville – fanned out further along the coast, trying Sotteville, Veules, Vattetot and other small resorts towards Fécamp and Etretat where the sea and the cliffs were not so different from those at Dieppe. Something of this survived the war, when Sickert returned to Envermeu with his short-lived second wife Christine, and the climate of those times is brought delightfully to life in Simona Pakenham's memoirs. But artists and their followers were no longer so keen on green fields and woods, or the soft seaside light with its implied threat of rain, let alone the tortures of a stony beach. And the newcomers of the 1920s, whether abstract or surrealist, did much of their painting in the studio, not in the lucid open air.

The Mediterranean took over from the Channel. But it did not appeal to everyone, nor did it appeal all the time. Albert Roussel the composer, a former ship's officer, found a house near the Ailly lighthouse, where he could keep an eye on the sea. Braque, who made his transition to Cubism in the south and in Paris, had been brought up in Normandy, and from 1929 on he was partly based at Varengeville, where the stones and the cliffs and the fishing boats entered many of his pictures, and he and his wife became part of the beach scene right into their old age. Paul Nelson, the American architect, had a house there, where his radical friends such as Calder, Léger and Miró visited him in the 1930s; after World War II he and Léger would work on the new hospital at Saint-Lô beyond Bayeux. André Breton wrote his surrealist novel *Nadja* there; Louis Aragon his *Traité du Style*. Christopher Wood stopped off in Dieppe in the spring of 1929, found the place congenial and painted a number of pictures. Ben Nicholson, who like him might have been reminded of the blue sea and fishing boats in Cornwall, knew Braque and came to Varengeville several times with Barbara Hepworth; there are echoes of Normandy and Dieppe (Bocquet's mustard, the shoeshop called 'Puss in Boots', the *Journal de Rouen*) in the paintings from their show at Tooth's in 1932. Gwen John collapsed and died in Dieppe on her way to the Newhaven boat at the start of World War II. Roger Hilton was captured in the Anglo-Canadian raid of August 1942. The connection goes on.

This has been a brief outline of some French influences on the English and vice versa, particularly as they affect the visual arts. On the one hand they helped to form the New English Art Club and the London Group; on the other they stimulated the art of landscape painting and brought a new poetry into French art – as seen in Moreau and Puvis de Chavannes – without which Surrealism might not have come about. They cannot be treated as clear-cut schools and isms once one looks at the evidence of Dieppe, for the stimulus of the place itself dominates, even right into the 1930s: a particular *genius loci* comes through. The background keeps shifting as the town grows: its communications improve, the system of government veers from one direction to another. The part played by the other arts alters, becoming more evident the more they interact. Nor can Dieppe's evident appeal to eccentrics and adventurers of one kind and another be wholly coincidental; the diversions offered by personalities like the de Meyers, Maundy Gregory, Edward VII, Winston Churchill's mother-in-law, and Krishnamurti, are rich in human interest and oddity. And so is the sheer courage of others of the English colony: Forrest Yeo-Thomas GC, the 'White Rabbit' of the French resistance in World War II, the Seagrim brothers, who won the VC and GC, sons of a major who ran a Dieppe cramming establishment.

There is so much to look at and so much still implicit in it. Perhaps its study will suggest what is so special about a point where the peculiar subtleties of two great European cultures meet.

RIGHT
J.M.W. TURNER
84. *Château d'Arques, nr Dieppe* 1834
watercolour on paper, 9.5 × 14.6 cm
By permission of the Provost and
Fellows of Eton College

BELOW
Richard Parkes BONINGTON
10. *Pays de Caux : Twilight* 1823
oil on canvas, 31.1 × 41 cm
Manchester City Art Galleries

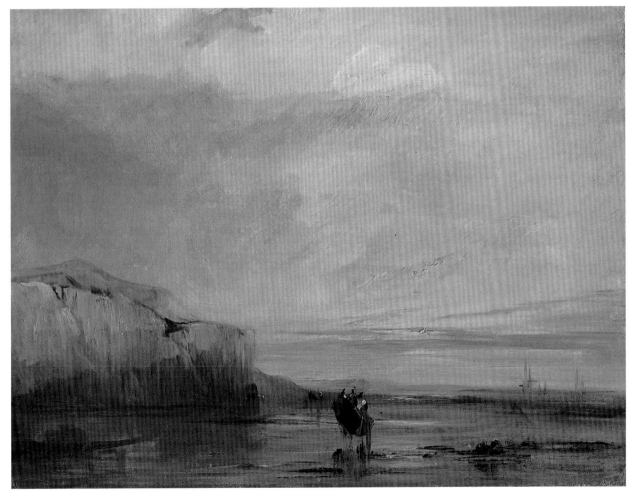

Louis-Gabriel-Eugène ISABEY
40. *Fish Market, Dieppe* 1845
oil on panel, 35.6 × 53 cm
The Trustees of the National Gallery, London

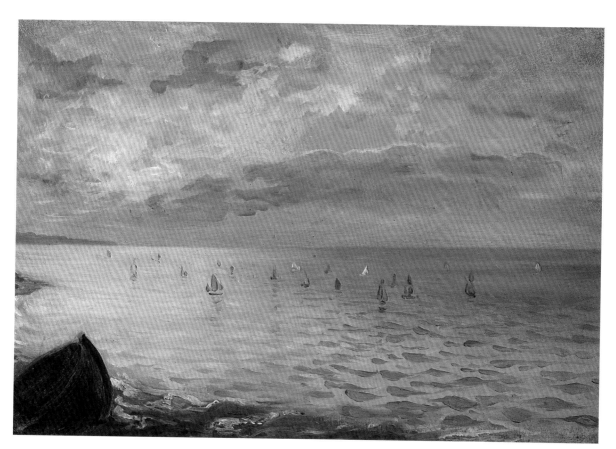

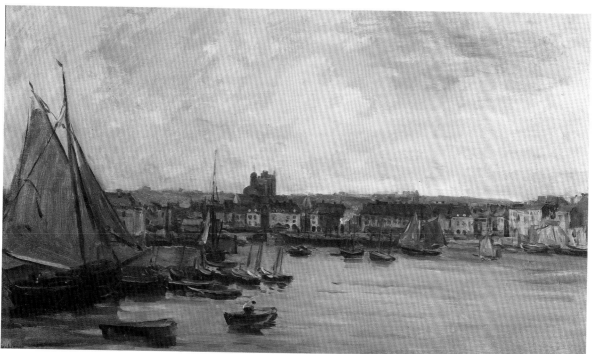

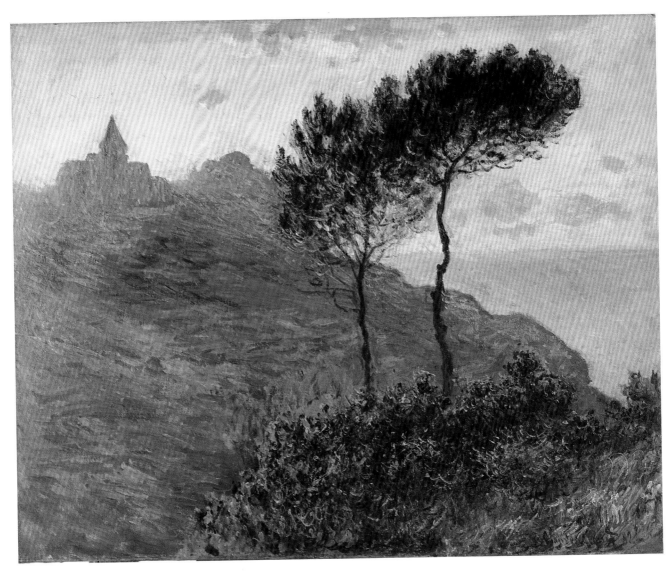

Claude MONET
49. *Varengeville Church (L'Eglise de Varengeville à Contre-Jour)* 1882
oil on canvas, 65 × 81 cm
The Barber Institute of Fine Arts, The University of Birmingham

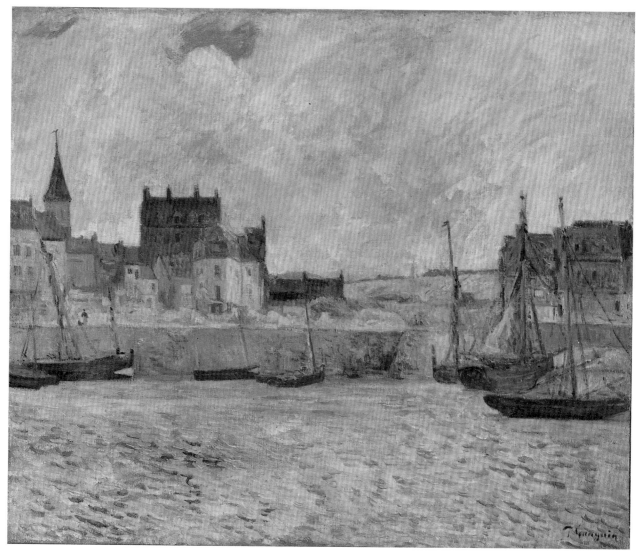

Paul GAUGUIN
23. *Harbour Scene, Dieppe* (*Le Port de Dieppe*) 1885
oil on canvas, 60.2 × 72.3 cm
Manchester City Art Galleries

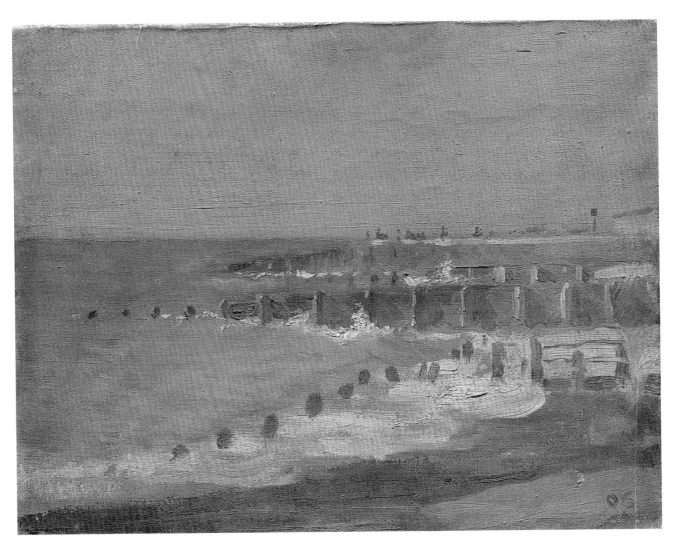

Otto SCHOLDERER
64. *Marine*
oil on canvas, 24.5 × 51.8 cm
Paris, Musée d'Orsay
© Photo R.M.N.

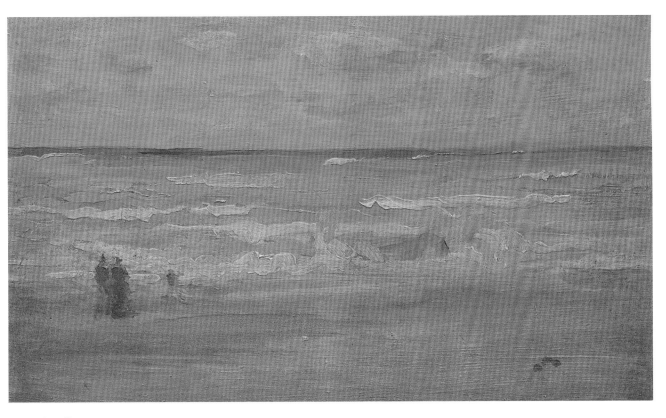

James McNeill W H I S T L E R
The Shore, Pourville 1899
oil on wood panel, 14 × 23 cm
The Visitors of the Ashmolean Museum,
Oxford

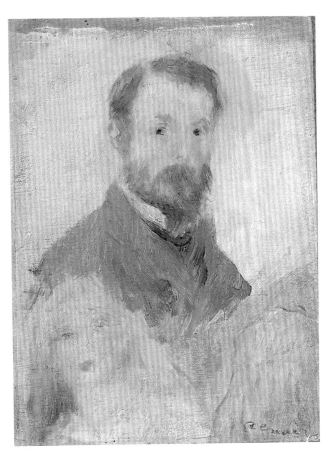

Auguste RENOIR
58. *Self-portrait* (*Portrait de l'artiste*) 1879
oil on canvas, 18 × 14 cm
Paris, Musée d'Orsay
Cliché des Musées Nationaux

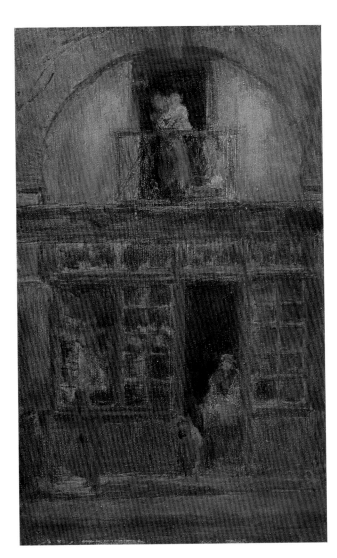

James McNeill WHISTLER
88. *A Shop with a Balcony c.* 1897
oil on panel, 22.3 × 13.7 cm
Hunterian Art Gallery, University of Glasgow (Birnie Philip Bequest)

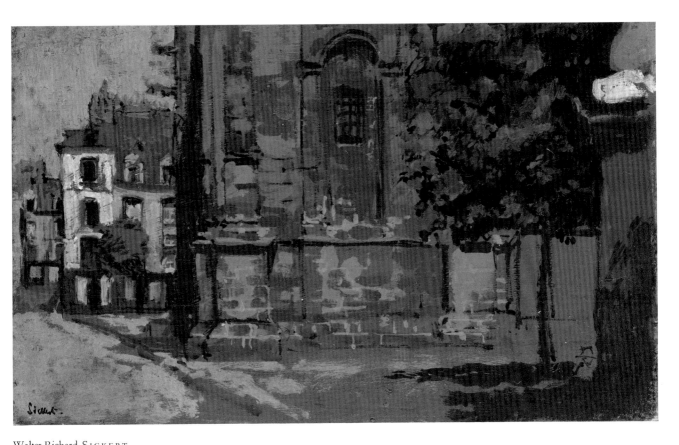

Walter Richard SICKERT
73. *Saint Rémy c.* 1900
oil on canvas, 14 × 24 cm
Private Collection
Photograph courtesy Browse & Darby Ltd

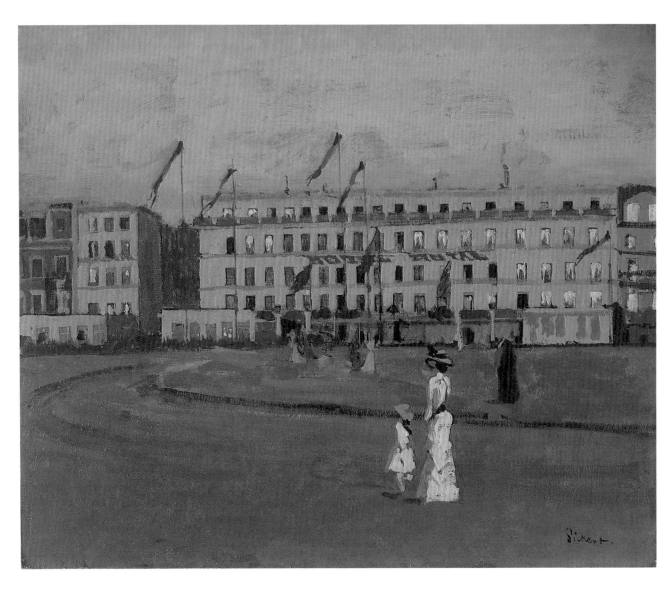

Walter Richard SICKERT
67. *L'Hôtel Royal, Dieppe c.* 1894
oil on canvas, 50.5 × 61 cm
Sheffield City Art Galleries

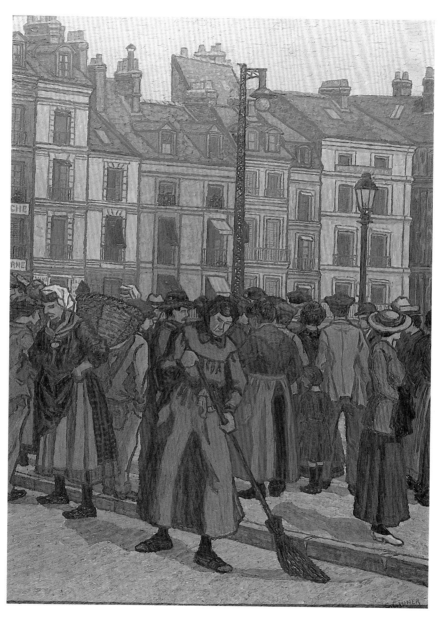

Charles GINNER
30. *La Vieille Balayeuse, Dieppe* 1913
oil on canvas, 61 × 46 cm
Natalie Bevan
Photo Roy Farthing

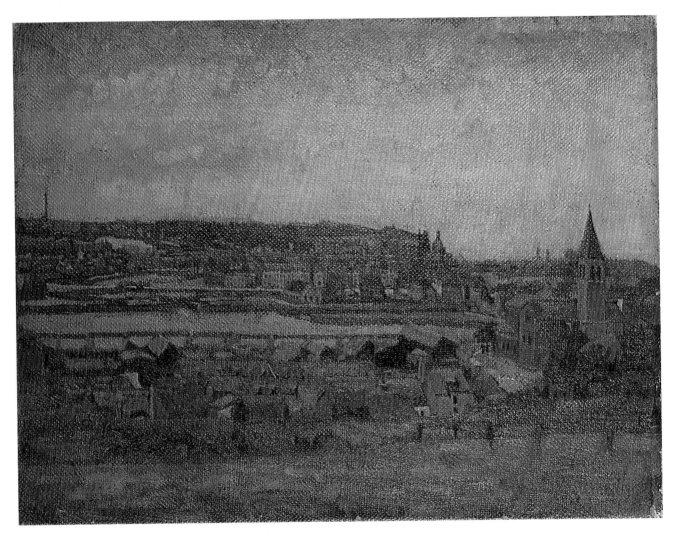

Spencer GORE
32. *View of Dieppe* 1906
oil on canvas, 24 × 32 cm
Private Collection
Photo John Cass

William NICHOLSON
53. *Hoisting the Flag, Customs House, Dieppe*
c. 1910
oil on canvas, 33 × 28 cm
Private Collection

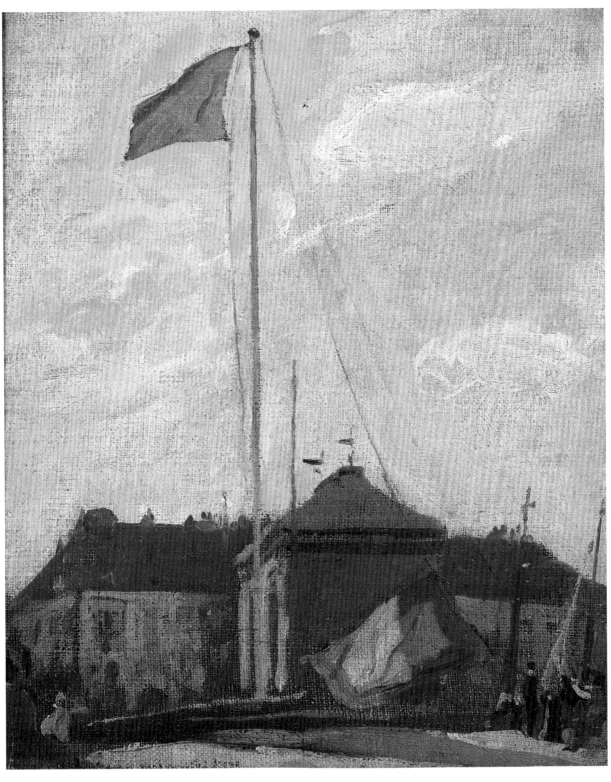

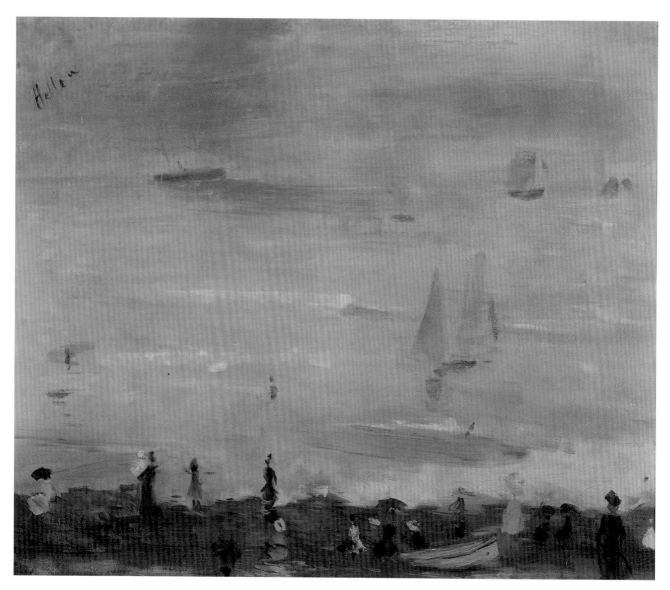

Paul HELLEU
38. *Dieppe Beach* (*Plage à Dieppe*) 1885
oil on canvas, 50 × 60.5 cm
Musée des Beaux-Arts, Rouen

Charles CONDER
16. *Beach Scene, Dieppe* 1895
oil on canvas, 33 × 44.5 cm
Sheffield City Art Galleries

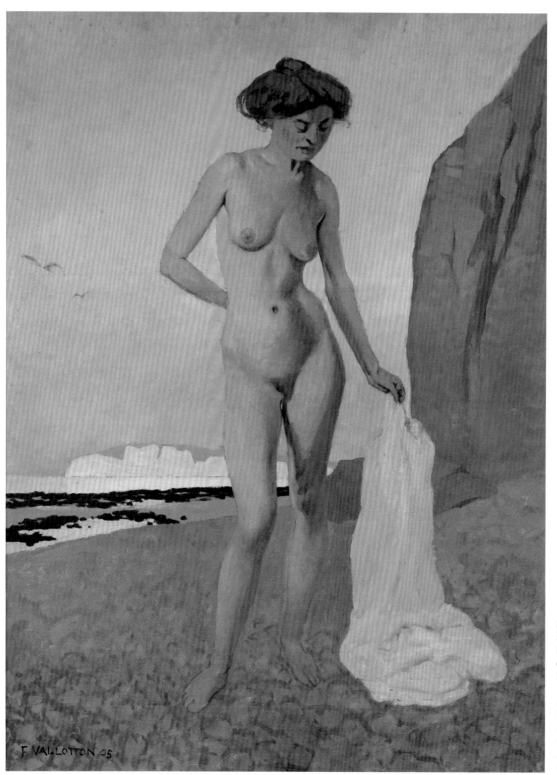

F. VALLOTTON .05

No ordinary visitors: Dieppe at the *fin de siècle*
Anna Gruetzner Robins

IN AUGUST 1888, the novelist and critic George Moore spent four days in Dieppe with Jacques-Emile Blanche, painter and former pupil of Renoir. Since his first trip to Dieppe in 1885, Moore had been a frequent visitor to Bas-Fort Blanc, the Blanche family home, where Blanche had a studio and lived with his parents. On his return to London, Moore wrote to Blanche:

> I have only just ceased to talk about Dieppe: I have described the town over and over again and told my friends about you and your pictures and our controversy and how much I enjoyed myself... Really I do not think I ever spent a pleasanter four days and certainly not the least pleasant part was the time I spent with Gervex walking about the town. I shall never forget the town, it is engraved on my mind... My whole visit was one pleasure – your studio, Dujardin's kindness in translating my 'copy', the sea shore etc. etc. etc.[1]

Moore and Blanche were well suited. Blanche was an anglophile who was happy to share his knowledge of Impressionism and other types of French painting with his many artist and writer friends in England. Moore was an equally enthusiastic francophile, who experimented with naturalist and Symbolist prose, had a keen interest in French Impressionism, and was one of the first critics of the new English painting of the London Impressionists. The casual references in Moore's letter to Henri Gervex, a successful Salon painter, and Edouard Dujardin, the influential founder of *La Revue Wagnérienne* and the other better-known Symbolist journal, *La Revue Indépendante*, gives an inkling of the central role Blanche played in bringing together French and British artists and writers during the last two decades of the nineteenth century. Over the years Blanche was host to many French artists – Monet, Pissarro, Renoir, Degas, Helleu, Puvis de Chavannes (there in 1895), and it was their meetings with them, and writers, critics and poets which were so fruitful for the British. One particularly eventful summer had been in 1885. Degas used Blanche's studio to draw his pastel group portrait of Sickert, Ludovic and Daniel Halévy, Gervex, Albert Cavé, and Blanche, and Whistler delivered his 'Ten O'Clock' lecture to the summer crowd.[2]

Blanche had a large collection of Impressionist pictures,

including seven Monets, four of which he certainly owned by 1888, a Degas, eight Manets, three Morisots, five Renoirs, two Cézannes, a Corot, a Rousseau and several Sickerts. The majority of these pictures had been acquired by the mid 1880s. During the winter months some of them hung in Blanche's Paris studio.[3] They may also have been on view in Dieppe.

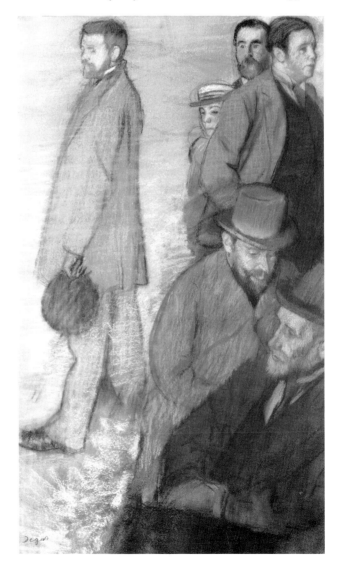

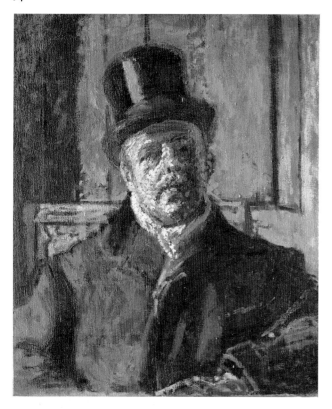

Walter Richard SICKERT
79. *Portrait of J-E. Blanche c.* 1910
oil on canvas, 61 × 50.8 cm
The Trustees of the Tate Gallery

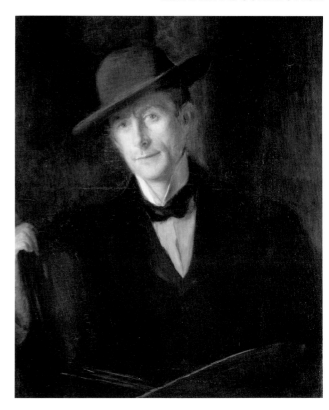

Jacques-Emile BLANCHE
6. *Portrait of Walter Sickert* 1898
oil on canvas, 79.5 × 64.8 cm
National Portrait Gallery, London. © DACS 1992

The reference to 'controversy' with Blanche in Moore's letter probably concerned Blanche's insistence that the painter must remain true to naturalism and 'paint the things and places he has seen all his life'. This too was Sickert's aim as he embarked on a long career as the painter of Dieppe. With its fashionable summer crowd, cafés, *bals*, beach and casino, Dieppe was a haven for artists who wished to emulate the Impressionist pictures of middle-class leisure and enjoyment. Sickert set out to record these aspects of the town in the summer of 1885, painting the crowd at the Bastille Day celebrations and the Dieppe races. But this initial interest did not develop and by the early 1890s the Café des Tribunaux, a favourite meeting place for artists and writers in Dieppe, and the Hôtel Royal, had replaced the earlier 'modern life' pictures.

The art of the new English painters and Decadent poets of the 1890s was about the bizarre and artificial aspects of London society, which they viewed as a tragi-comedy with its principal characters in masks and masquerade. They would meet for supper at the Cock Tavern, then on to the Tivoli and the Empire Leicester Square, two West End music halls, or further afield to the Bedford in Camden Town, then back to the Crown, a West End public house. It was after a night of heavy drinking at the Crown in 1895 that Aubrey Beardsley, the painter Charles Conder, and the poet Ernest Dowson set off without luggage on the early morning boat train to Dieppe. What was intended as a brief sojourn became a more prolonged stay. 'I had meant to get back to town . . . [but] missed the boat to go, stopped on here indefinitely', Beardsley wrote. 'Really Dieppe is quite sweet.'[4]

This jaunt appears to have taken place in July 1895. The following month, at Conder's urging, Arthur Symons arrived in Dieppe. He took a room opposite the Gothic church of Saint Jacques, in the house on the rue de l'Oranger where Conder was staying. An intended three-day outing was to last two months.

Compared to polluted, foggy London and its huge

metropolitan sprawl seen under the camouflage of night, Dieppe was dazzling – 'altogether having the most amusing and irresponsible holiday I have had for a long time', wrote Symons.[5] He settled in to stage-manage the English group.

Symons had learnt a lot about bohemianism from books. He had a reputation as a serious poet, critic, and translator of French Symbolist poetry. He had met Mallarmé and

Verlaine, and had spent time in Toulouse-Lautrec's company at the Moulin Rouge in Paris, as did Conder. George Moore had probably told him endless stories about the Nouvelle-Athènes and Tortoni's, Paris cafés which were meeting places for the French Impressionists. Symons sensed that such milieus were a central part of the bohemian artist's existence. Beardsley, Conder and Symons were the mainstay of the English group at Dieppe in 1895. Dowson moved out of the town after a few weeks but came to see his English friends. The novelist Conal O'Riordan, the Rhymers Club poet George Green, and the artist William Rothenstein were some of the others who came and went that summer.

Walter Richard Sickert
66. *Café des Tribunaux c.* 1890
oil on canvas, 60.3 × 73 cm
The Trustees of the Tate Gallery

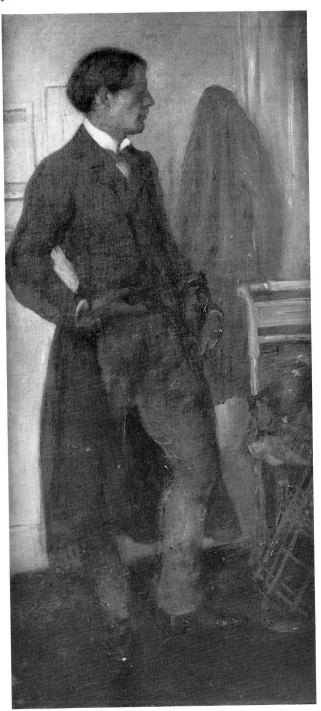

William ROTHENSTEIN
59. *Charles Conder* 1896
oil on canvas, 121.5 × 56 cm
Paris, Musée d'Orsay. © Photo R.M.N.

Symons's account of Dowson in the *Savoy* is the first indica‚
tion that he was consciously constructing a bohemian demi‚
monde for his friends in Dieppe. The Dowson legend had
begun in London. Soon after they met, Dowson took Symons
to eat at a cabman's shelter.[6] These 'low' surroundings made
Dowson feel most comfortable, Symons said. According to
Symons, Dowson's need to seek out sordid places continued
in Dieppe 'where I saw so much of him one summer, he dis‚
covered strange, squalid haunts about the harbour, where he
made friends with amazing innkeepers, and got into rows with
fishermen who came in to drink after midnight'. The more
'he soiled himself at that gross contact', the more his fantasies
would overtake him, 'seeing himself moving to the sound of
lutes, in some courtly disguise, down an alley of Watteau's
Versailles'.[7] These quaint fantasies inspired Dowson's poetry:
I have 'Flung roses, roses, riotously with the throng.'[8]

If Ernest Dowson's role in Symons's bohemian dream was
that of the dissolute pretender to Dieppe's lowlife, then Charles
Conder was its drunken Casanova, whose sexual conquests
were matched only by those of Symons himself. Conder's per‚
sona was 'half feminine and half masculine, both for men and
women'[9] and he hid his seriousness in 'a delightfully incon‚
sequent mind & manner of conversation,[10] which Oscar
Wilde likened to 'a beautiful sea mist' when they met in
Dieppe in 1897.[11]

Aubrey Beardsley hardly needed lessons from Symons in role
playing. During his mercurial rise to prominence, Beardsley
constructed an elaborate persona based on the sartorial, artistic
dandy. He could be sighted at Dieppe carrying 'his large, gilt‚
leather portfolio with the magnificent, old red‚lined folio page,
which he would often open to write some lines in pencil'.[12]
Beardsley always wore gloves and carried a cane. During the
day he donned a light grey costume, with a flower in his but‚
tonhole. Blanche compared him to a young London dandy
from Hogarth's *Marriage à la Mode*. In Blanche's portrait
(painted August 1895, cat. 4), Beardsley, with his two black
beauty spots, 'like the patches worn by coquettes'[13] is posed
out of his class, in another time, in the manner of an eighteenth‚
century English aristocrat.

Symons also posed in Blanche's studio 'where he paints the
passing beauties as they fly'. Self‚consciously smart, he was
delighted to be meeting 'Baronesses and chahuteuses from
Bullier, bathing, lounging about the Casino'.[14] His friends
had other views. Symons, Conder said, was 'too awful for
words but very good hearted. He has decked himself out in
a whole suit of French summer clothing from the Belle
Jardinière, and although it suits his particular style very well
one is not exactly proud of his companionship.'[15] Blanche

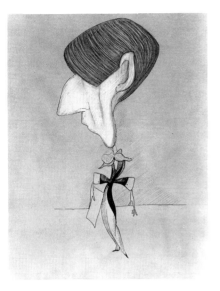

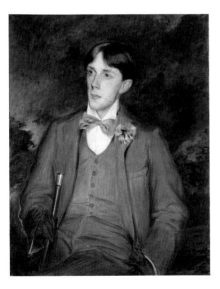

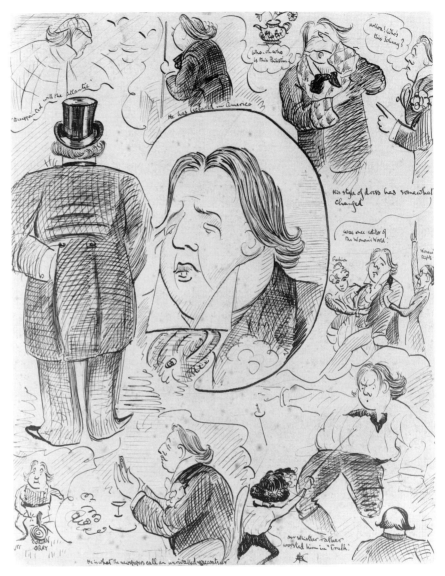

TOP
Max BEERBOHM
2. *Aubrey Beardsley c.* 1894
pen and ink on paper, 27.8 × 23.2 cm
The Visitors of the Ashmolean Museum, Oxford
Reproduced by courtesy of Mrs Eva Reichmann

LEFT
Jacques-Emile BLANCHE
4. *Portrait of Aubrey Beardsley* 1895
oil on canvas, 90.2 × 71.7 cm
National Portrait Gallery, London
© DACS 1992

ABOVE
Max BEERBOHM
3. *Oscar Wilde* 1894
pen and ink on paper, 30.9 × 19.2 cm
The Visitors of the Ashmolean Museum, Oxford
Reproduced by courtesy of Mrs Eva Reichmann

also painted a portrait of the artist Florence Pash, who ran a school with Sickert and Beardsley's friend, Marie Tempest; the actress whose stage name was Madame Réjane on the English stage also sat for him. But for the most part women moved on the fringes of this male-centred self-consciously bohemian group, as mistresses or more casual acquaintances.

The Symons set's ambivalence towards women was tested on the Dieppe beach. They were no ordinary summer visitors. Drawn to the beach where male and female bathed together, unlike the segregated beaches in England, Symons translated this modern scene of women parading in summer dresses, or emerging from the sea half-clothed, into a pageant of frivolous,

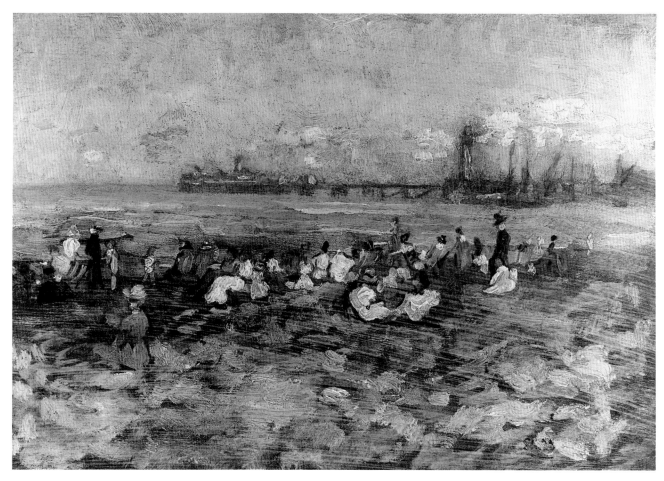

Arthur STUDD
The Beach, Dieppe c. 1894
oil on panel, 15.25 × 20.25 cm
Private Collection

artificial splendour: 'the bright dresses glitter in the sunlight, like a flower garden; white peignoirs, bright and dark bathing costumes, the white and rose of bare and streaming flesh.'[16] Conder also expressed his 'delight' in the 'fashion and felicities of a whole summer' in *Beach Scene, Dieppe* (cat. 16), with its sauntering women in dark skirts, white high-necked blouses and wide, flat straw hats. This casual grouping of a summer crowd also reveals certain tensions between the clothed and semi-clothed women. A female bather stands in the foreground, lifting a white robe to reveal her bathing costume, tightly moulded against her legs and hips, in a manner more reminiscent of an intimate boudoir scene, than of one on the beach. Symons, that paramour of numerous music-hall stars

and ballet dancers, thought, however, that the women hurrying to and fro between bathing machines and the sea formed a grotesque parade. The men who were well built were appealing, he said, but the women bathers were repulsive. 'The lines of the body are lost or deformed; there is none of the suggestion of ordinary costume, only a grotesque and shapeless image, all in pits and protuberances.'[17] Nor were Beardsley's *Bathers* (cat. 1) ordinary late-Victorian belles. They flaunt physiques, the result of the newly discovered athletic skills, bathing and riding bicycles; two popular pastimes for women at Dieppe. Everyday life was the starting point, but Beardsley disrupted these surface appearances, adding and embellishing from a catalogue of details. With froufrou and lace, regulation bathing costumes are like elaborate lingerie, and the fully dressed matron (a common sight on the beach) a hovering 'madame'. Beardsley celebrated women's sexuality, ignoring stereotypes of class and social position. His erotic disclosures were disquieting because they tested conventional standards which denied

women sexual feelings. But they still represent women as erotic objects, to be gazed at voyeuristically and relished.

Beardsley's *The Moska* was another drawing based on 'everyday' life at Dieppe. The moska was a dance performed at the Bal des Enfants which was held periodically at the Casino. The 1890s' cult of the child had many followers. Dowson, 'that adorer of childhood', celebrated a bizarre infatuation in his own poems. The critic Frederick Wedmore's short story, *To Nancy*, laments the passage from childhood into ripening puberty.[18] Smithers, publisher and pornographer, indulged in its more sinister aspects, and Symons detested the physical change from child to young woman. 'I hate to think of those long, thin legs getting stouter, and being covered up in skirts.'[19] Beardsley's figure is ostensibly a child guest at Dieppe's 'delicious' dance, but subversively Beardsley's child has a knowing, almost leering expression as she plays

Gerald KELLY
42. *The Promenade, Dieppe* 1906
oil on canvas, 26.6 × 20.9 cm
Michael Parkin Gallery, London

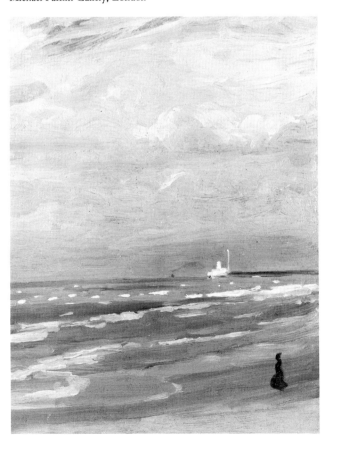

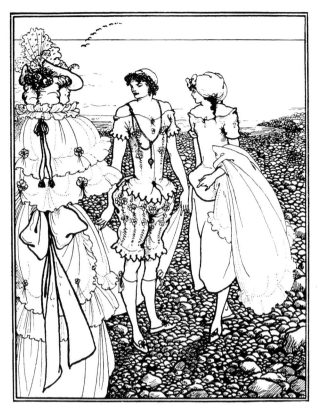

Aubrey BEARDSLEY
1. *The Bathers*, plate cut from the *Savoy*, No. 1, January 1896
The Board of Trustees of the Victoria and Albert Museum

a social game usually enacted by her elders. At another level the cult of the child reflects a fear of women's sexuality, a dissatisfaction with the present and a longing for a more golden past.

The new English painters sought the fleeting surface of earlier modes and styles of art. The fascination with the year 1830, for example, did not originate at Dieppe but it did blossom there. Paintings by William Rothenstein and Conder of female figures in romantic 1830s' dress mark the start of their restless search for other ways of painting. The Dieppe *plage* was the perfect physical embodiment of this flirtation with 1830. The 'old fashioned distinction', the 'faded lawns by the sea', 'the line of white hotels'[20] beyond (seen in the background of Conder's *Dieppe*, cat. 15), gave it an 1830s' air, which for Conder and Beardsley evoked Balzac. The old Hôtel Royal with its low, elegant white-painted façade, and the other white housefronts, had been built soon after Louis Philippe came to the throne, the lovely little theatre a few years earlier, and the rose-covered Casino with its 'amusing minarets and oriental cupolas'

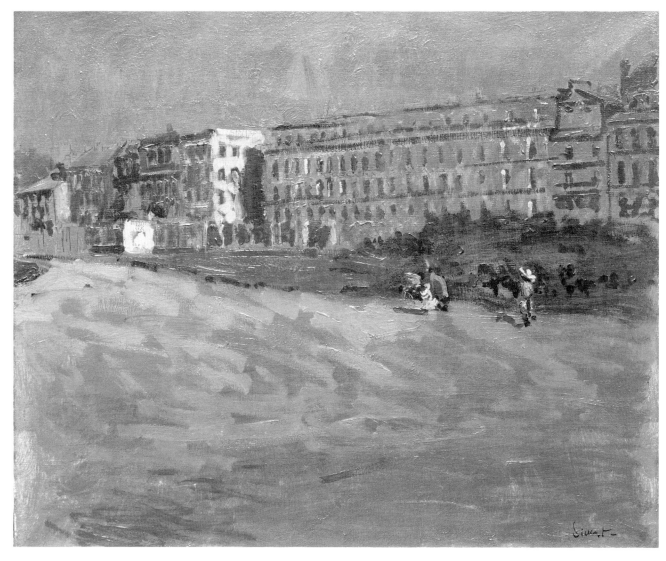

Walter Richard SICKERT
68. *L'Hôtel Royal, Dieppe c.* 1899
oil on canvas, 46.3 × 61 cm
Ferens Art Gallery, Hull City Museums & Art Galleries

where Beardsley passed his days, as late as 1880. Sickert, who said that the Hôtel Royal had 'left its mark on my talent', painted two early versions that evinced strong *fin de siècle* longings for bygone days. Just as Whistler had used green and violet to evoke the mood of melancholy twilight while painting at Dieppe in September 1885, Sickert, too, used this palette for a similar effect. One version has a twilight, violet sky, while the white façade of the hotel is cast in grey-green

shadow; another version (untraced) had figures in full, white crinolines ambling in the foreground.[21] Symons recalled these pictures in his poem to Sickert, 'At Dieppe' (dated 16 September 1893). Here too Symons used the green and violet colours of the fading summer light, to convey a mood of nostalgic longing for past time: 'The long hotel, acutely white,/Against the after-sunset light/Withers grey-green, and takes the grass's tone.'[22]

While reading Balzac, Conder, who Symons said had a temperament of 1830, also saw these echoes of time past in Dieppe society, saying that it 'contained all the youth and beauty of the decayed aristocracy of France'. The assembled group of saints, heroes and fashionable beauties, in the medal-

lion portraits painted on silk in the room that Conder designed for an exhibition at Samuel Bing's premises (so important to the promotion of Art Nouveau) in the autumn of 1895, were a microcosm of the imaginary crowd Conder saw parading at Dieppe. Other figures who flitted in and out of Dieppe that summer had more frivolous connections with 1830. There was Cléo de Mérode, the ballet dancer at the Opera who wore her hair parted in the middle in the style of a 'fashionable 1830 beauty'. There was Edouard Dujardin, who was still a regular visitor at the Blanches.

At Dieppe Dujardin was 'fantastic in 1830s clothes – crimson waistcoat, brass buttons, tight dove grey trousers strapped under varnished leather pumps'.[23] (Dujardin was surely the prototype for the inquisitive boy in 1830s' costume in Beardsley's illustrated poem, 'The Three Musicians' (*Savoy*, January 1896).)

This 1830s' style can also be seen in Conder's woodcut illustrations for Balzac's *La Fille aux Yeux d'Or*,[24] which Conder made in Beardsley's hotel room at Dieppe. According to Blanche, Conder read Balzac because he wanted to make 'romantic' illustrations. While staying in Dieppe, Leonard Smithers commissioned Dowson to translate the novel and Conder to do six illustrations. The frontispiece of cameos set into an elaborate neoclassical setting is festooned with garlands of roses and ribbons. The rest show characters in period costume acting out scenarios of sexual intrigue and death.

The Beardsley drawings mentioned here, and Conder's frontispiece, were published in the *Savoy*, the shortlived (January–December 1896) artistic and literary journal. Earlier in the summer of 1895, Smithers had appointed Symons as editor. Beardsley, who had been recently ousted from the *Yellow Book* in the 'moral panic' which followed Oscar Wilde's trial and imprisonment, was appointed as the *Savoy*'s art director. Symons said that 'it was at Dieppe that the *Savoy* was really planned' in the Café des Tribunaux where 'I wrote the slightly pettish and defiant *Editorial Note* which made so many many enemies for its first number'.[25] Symons stressed the *Savoy*'s élitist role, saying that it had no particular attachment to one group or ism, nor was it interested in social purpose. Much of the conversation at Dieppe centred around the planning of the *Savoy*, as Symons and Beardsley saw each other every day for a month. Their close companionship effected many other collaborative projects. For example, Symons's translation of *Mandoline*, one of Verlaine's *Fêtes Galantes* poems (January 1896): 'And the mandolines and they/Faintly breathing, swoon/Into the rose and grey/Ecstasy of the moon.' It was illustrated by a wood-engraving from a watercolour by Conder, representing a pastoral scene of lovers and

mandoline players in a Watteau landscape, framed by an arabesque-patterning of curving lines. 'One almost heard the touch of the player's hand on the mandoline, himself half a vision and half a shade.'[26] Conder's taking up of an eighteenth-century style, at the same time that he was using oil-painting techniques based on French Impressionism, is one characteristic of English decadent art and literature. But it should not be assumed that Conder used one style for illustration and the other for painting. The willingness to adopt and discard various styles and techniques is symptomatic of the stylistic dissolution in both disciplines as they challenged earlier classical forms.

Beardsley's parody of the tale of Venus and Tannhäuser, which he started to write in earnest at Dieppe in late summer 1895, is another example of this disregard for a coherent literary style and visual effect. While Beardsley sat for his portrait and worked in Blanche's studio, he would have seen Renoir's murals of Venus and Tannhäuser there (1879). They had been commissioned by Blanche's father, an avid Wagnerite at a time when Wagner was still unpopular in France as a result of the Franco-Prussian war. In this decade, when word and image were so closely connected, Renoir's reinvention, in the manner of Fragonard, of a voluptuous nude Venus who welcomed Tannhäuser surrounded by fluttering cherubs in a vaporous delicate landscape, should be mentioned. Beardsley also set his Venus and Tannhäuser in an artificial eighteenth-century landscape. However, Beardsley's Venusberg is more than the scene of ecstatic, heterosexual coupling. A host of attendants who were thinly disguised portraits of Conder and Wilde, among others, practise every conceivable form of carnal love, described in 1890s' camp slang.[27]

In his preface to *La Fille aux Yeux d'Or*, Dowson said that he had been drawn to the story because the characters 'make themselves wings with which to scour society from top to bottom'. In their role-playing and adoption of different guises, the 1895 group at Dieppe wanted to be like Balzac's thirteen kings, and in doing so recapture the bohemianism of the men of 1830.

Symons's essay on Dieppe (*Savoy* January 1896) is a chatty account of his stay there. Like all good tourists he points out the highpoints of the townscape and its architecture. He liked the Gothic church of Saint Jacques, for its permanence and impermeability. He praised a particular aspect of the Place Nationale on market day with its statue of Duquesne. He pointed out the charms of an old curiosity shop in the rue de la Barre, and the Arcades near the harbour and the local café concerts. The fishing quarter, Le Pollet, was most picturesque, and the contrast between the modern rue Aguado along the front and the dark narrow streets behind made a

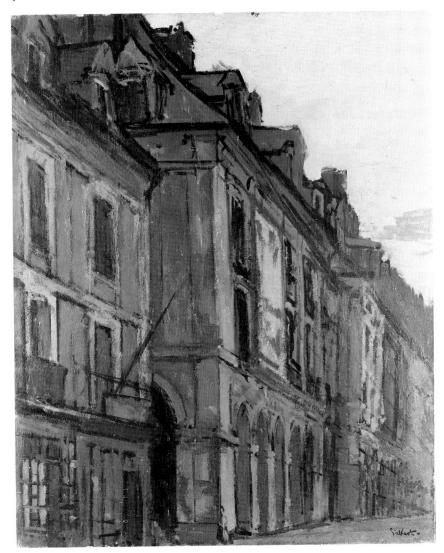

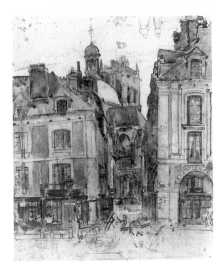

Walter Richard S I C K E R T
69. *Dieppe, la rue Notre-Dame c.* 1899–1900
watercolour, ink and pencil on paper,
26.5 × 22.5 cm
Musée des Beaux-Arts, Rouen

Walter Richard S I C K E R T
71. *Les Arcades de la Poissonnerie, Dieppe c.* 1900
oil on canvas, 61 × 50.2 cm
The Trustees of the Tate Gallery

memorable impression. Curiously, Symons's travelogue sup-
plies the prescriptive list of the picturesque aspects of Dieppe
that Sickert painted when he was based at Dieppe between
1898 and 1905. Sickert was more bohemian than any of those
in Symons's set. When he settled at Dieppe he had no interest
in parodic images of the people he encountered there. Nor
was he inclined to reinvent a fantasy vision of modern life.
Instead, the picturesque motifs at Dieppe were the starting
point for obsessive introspective experiments. The broad hand-
ling, complex patterns and vivid colours of these paintings
reflect a modernity that was very different from that of the
crowd of 1895.

Notes

I would like to thank David Robins for his help.

1. Letter to J.E. Blanche, August 1888, in R. Becker, *The Letters
of George Moore 1863–1901*, unpublished Ph.D thesis, University of
Reading, 1980.

2. Degas, *Six Friends at Dieppe*, 1885, (Lemoisne 824), coll. Rhode
Island School of Design, Providence.

3. Blanche's collection included the following pictures:
M O N E T : *Vue de la Plaine à Argenteuil*, acquired 1884, (Wildenstein
220), *La Chaumière*, acquired 1880, (Wildenstein 524), *Marine,*

Pourville, acquired 1882, (Wildenstein 713), *La Route devant la Ferme Saint-Siméon, L'Hiver*, (Wildenstein 79), *Au Pont d'Argenteuil*, (Wildenstein 321), *Bordighera, Italie*, and an unidentified Vétheuil scene.

DEGAS: *The Rehearsal*, (Lemoisne 430).

MANET: *Etude pour le Déjeuner*, acquired 1880, (Jamot-Wildenstein 347), *Scène d'Atelier, Espagnol*, (Jamot-Wildenstein 25), *Berthe Morisot*, (Jamot-Wildenstein 177), *Portrait d' Alice Legouve*, (Jamot-Wildenstein 242), *Portrait de Courbet*, (Jamot-Wildenstein 4770), all acquired in 1884, *Méry Laurent à la Toque*, (Jamot-Wildenstein 74), *Portrait de Madame Brunet*, (Jamot-Wildenstein 31) and *Moine en Prière*, (Jamot-Wildenstein 104).

MORISOT: *Jeune Fille Assise avec Ombrelle, Un Passage de Meulan, Tête de Jeune Fille*.

RENOIR: *Nini Tricotant Tête Baissée, Passage des Princes, The Large Bathers*.

4. Letter from Beardsley to William Rothenstein, *c.* July 1895, in H. Maas, J.L. Duncan and W.G. Good, *The Letters of Aubrey Beardsley* (London, 1970) p. 94.

5. Letter from Symons to Herbert Horne, postmarked 4 September 1895, in K. Beckson and J.M. Munro, *Arthur Symons Selected Letters, 1880–1935* (London, 1989) p. 111.

6. See 'A Literary Causerie: On a Book of Verses', *Savoy*, No. 4, August 1896, pp. 91–3. Unsigned but acknowledged to be by Symons.

7. See *The Poems of Ernest Dowson*, with a Memoir by A. Symons (London & N.Y., 1905) pp. xvi–xviii.

8. E. Dowson, 'Non Sum Qualis Eram Bonae Sub Regno Cynarae', *Poems* (1905).

9. K. Beckson (ed.), *The Memoirs of Arthur Symons* (Pennsylvania & London, 1977) p. 185.

10. See M. Longaker, *Ernest Dowson* (Pennsylvania, 1967) p. 291.

11. Longaker, p. 291.

12. *Memoirs*, p. 171.

13. J.E. Blanche, *Portraits of a Lifetime* (London, 1937) p. 95.

14. Symons, *Letters*, p. 111. Blanche portrait of Symons (Tate Gallery).

15. Letter from Conder to William Rothenstein, 5 September 1895, in K. Beckson, *Arthur Symons A Life* (Oxford, 1987) p. 122. Beckson usefully sorts out the identity of X, as Symons was referred to in earlier references to this letter. Beardsley, on the other hand was deeply antipathetic to Conder by the end of the summer and refused Smithers's request to design the cover for *La Fille aux Yeux d'Or*.

16. A. Symons, 'Dieppe: 1895', *Savoy*, No. 1, January 1896, p. 86.

17. 'Dieppe: 1895', p. 87.

18. See the *Savoy*, Nos 1 & 2, 1896.

19. 'Dieppe: 1895', p. 92.

20. 'Dieppe: 1895', p. 84.

21. See W. Baron, *Sickert* (London, 1973) cat. 67 & 68.

22. A. Symons, *The Collected Works of Arthur Symons*, vol. 1 (London, 1927), p. 187.

23. J.E. Blanche, *More Portraits of a Lifetime* (London, 1939) p. 162.

24. H. de Balzac, *La Fille aux Yeux d'Or*, trans. E. Dowson with illustrations by C. Conder (London, 1896).

25. A. Symons, *Aubrey Beardsley* (London, 1899) p. 8.

26. *Memoirs*, p. 187.

27. See L. Dowling, 'Venus and Tannhäuser: Beardsley's Satire of Decadence', *Journal of Narrative Technique*, 7–8, 1977–8, pp. 26–41, and I. Fletcher, 'Inventions for the Left Hand, Beardsley in Verse and Prose', in *Reconsidering Aubrey Beardsley*, ed. R. Langenfeld (Ann Arbor & London, 1989) pp. 227–68. There are two texts of Beardsley's Tannhäuser. The first, censored by Beardsley, was published as *Under the Hill* in the *Savoy*, Nos 1 & 2, 1896. *Venus and Tannhäuser*, the second incomplete fragment, was published privately in 1907.

Ben Nicholson and Georges Braque: Dieppe and Varengeville in the 1930s

Sophie Bowness

IN THE SUMMER OF 1932 Ben Nicholson and Barbara Hepworth made a short visit to Dieppe. In the Grande Rue, the main shopping street, Nicholson discovered a shoe shop imaginatively named 'Au Chat Botté' (Puss in Boots).[1] The work which he painted on his return to London, *Au Chat Botté* (Manchester City Art Galleries), is a poetic development of the experience of looking through the window of this shop. Nicholson recalled: 'The name of the shop was "Au Chat Botté", and this set going a train of thought connected with the fairy tales of my childhood and, being in French, and my French being a little mysterious, the words themselves had also an abstract quality – but what was important was that this name was printed in very lovely red lettering on the glass window – *giving one plane* – and in this window were reflections of what was behind me as I looked in – *giving a second plane* – while through the window objects

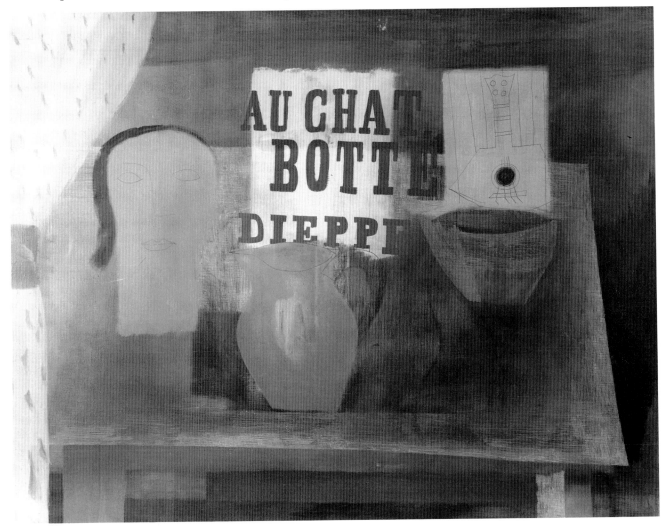

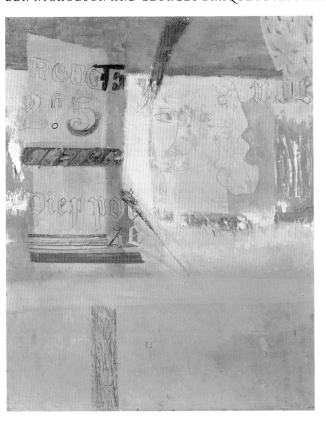

Ben NICHOLSON
51. *Auberge de la Sole Dieppoise* 1932
oil, gesso and pencil on board, 93.7 × 75.9 cm
The Trustees of the Tate Gallery
Reproduced by permission of Angela Verren-Taunt

OPPOSITE
Ben NICHOLSON
Au Chat Botté 1932
oil and pencil on canvas, 92.3 × 122 cm
Manchester City Art Galleries
Reproduced by permission of Angela Verren-Taunt

on a table were performing a kind of ballet and forming the "eye" or life-point of the painting − *giving a third plane*. These three planes and all their subsidiary planes were interchange-able so that you could not tell which was real and which unreal, what was reflected and what unreflected, and this created, as I see now, some kind of space or an imaginative world in which one could live.'[2]

At once playful, cool and mysterious, *Au Chat Botté* presents not a parade of shoes but a group of objects from Nicholson's personal repertoire − head, jug, bowl, shadowy guitar and schematic guitar − placed on a table tipped up onto the picture plane.[3] The head is both the painted counterpart of Hep-worth's sculpted heads and her face reflected in the window pane.[4] In the companion piece to *Au Chat Botté*, the *Auberge de la Sole Dieppoise* (cat. 51), another head which bears a likeness to Hepworth is reflected in − and placed inside − the window of the Auberge de la Sole Dieppoise on the Place du Puits-Salé at the heart of Dieppe.[5] These two paintings are deeply informed by the later Cubism of Braque and Picasso, and at the same time quite distinctive and independent achieve-ments, among the most important of Nicholson's early works.

Nicholson's fine understanding of Cubism is evident in the spatial dialogues which he describes in his account of *Au Chat Botté*. In true Cubist vein, the letters function in a variety of ways: they are abstract marks on a flat plane, emphasizing the picture as a two-dimensional autonomous object; they have an evocative value; and they contribute to the spatial paradoxes which Nicholson fosters, for example the way in which 'DIEPPE' lies at once on the picture plane and behind the jug on the table. Nicholson's delight in writing inscriptions in French across his paintings, itself a Cubist innovation, is marked at this time. With a lightness of touch and glancing humour he crops 'Auberge' (inn) to create 'Aube' (dawn) and inscribes the day's price for red wine. The intimate level of reference and the wit of Braque's and Picasso's Cubism of 1912−14 were especially well suited to Nicholson's own temperament.[6]

In addition, his are the simple still-life objects beloved by Braque and Picasso. The still life was at the heart of Nichol-son's work throughout his life, as of Braque's.[7] While the heads in the two Dieppe paintings recall the sculpted heads found in Picasso's work from the mid 1920s, it was Braque who in 1908 had introduced the musical theme which was to be so important in Cubist art. His devotion to musical instruments was unparalleled, and he liked to surround himself with them in his studio. Nicholson followed suit, acquiring his own collection of instruments.[8] It is telling that musical instruments appear frequently in Nicholson's work in precisely the brief period (1932−3) when Braque was most important to him.

In these years Nicholson swiftly developed into one of the major figures in the modernist movement in England, while at the same time finding his place within the European avant-garde. Braque's example was of great significance to him in this process. Nicholson was a frequent visitor to France in the first half of the 1930s and he had regular contact with Braque, expecially in 1933 and 1934.[9] Nicholson also prized Picasso's work very highly, but they met only a few times.[10]

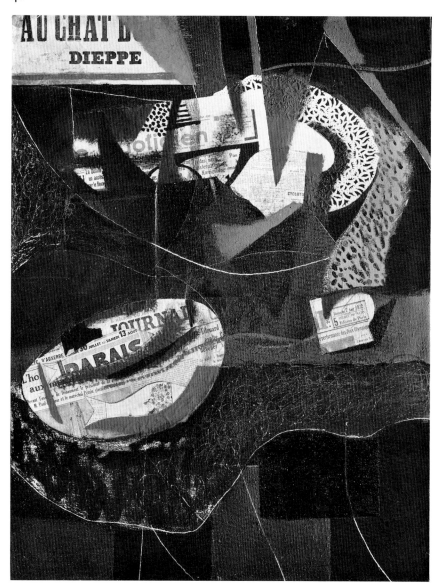

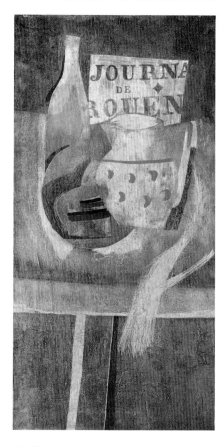

Ben NICHOLSON
Journal de Rouen 1932
oil on canvas, 91.5 × 46 cm

Ben NICHOLSON
January 27, 1933
oil and papers

Reproduced by permission of
Angela Verren-Taunt

By contrast, the warmth of the friendship with Braque is revealed in Braque's letters and postcards to Nicholson.[11] Despite the twelve-year difference in age between them, it seems to have been a relationship of equals. Soon after visiting Braque in Paris in January 1933, Nicholson wrote to Hepworth: 'He is a dear person – a big & simple person whom one is very fond of – a most beautiful thought'; he understands 'so simply and immediately'.[12]

The two painters soon discovered that they shared an attachment to Dieppe. Braque had recently had a house built for himself at Varengeville on the coast to the west of Dieppe;

and for his part, Nicholson's associations with Dieppe dated back to fondly remembered childhood holidays spent there.[13] Brief though it was, the Dieppe trip of 1932 was of great importance to Nicholson. His first visit to France for over two years, it gave rise to much of the work of subsequent months. A considerable proportion of the paintings shown by him in the exhibition he shared with Hepworth at Tooth's gallery in London at the end of the year were Dieppois.[14] Although it is now clear that Nicholson and Hepworth did not visit Braque on their short visit to Dieppe in August 1932 as has often been thought, they almost certainly did go to see him

twice in Varengeville in 1933, in April and again in Septem-
ber, and, as will be seen, they returned in the summer of 1937.[15]
It is fitting then that *Au Chat Botté* and the Dieppois paintings
should be so close in spirit to Braque.

Nicholson and Braque shared too a love of materials and
profound respect for artisanal qualities. The use of gesso in
Auberge, for example, creates a varied, tactile surface and
modifies the colour of the paint applied to it.[16] Exploring the
possibilities of the pasted paper collage (*papier collé*) invented
by Braque, Nicholson made a comic version of *Au Chat Botté,
January 27 1933*. In the top left-hand corner he sticks a scrap
of paper printed with 'AU CHAT BOTTE DIEPPE', from
which he derived the style of lettering used in the painted *Au
Chat Botté*. Beneath, he archly concocts the still life of a plate
of fish and mug out of a paper doily and fragments of the
newspapers he had read.[17] A second still-life collage painting,
Collage, 1933 is inscribed with 'DIPP' and 'BERN': Nichol-
son fragments 'BERNOT', a make of artists' materials he used,
to create a pun on the Swiss capital by analogy with Dieppe.

Nicholson unknowingly made several more still lifes which
were Dieppois by association, among them *Bocque 1932*
(cat. 50). Bocquet is the brand name of a well-known mustard
made in Yvetot, a small town in the centre of the Pays de
Caux between Dieppe and Le Havre. It was Braque who
revealed the connection when Nicholson showed him photo-
graphs of the works in January 1933. In this small group of
pictures Nicholson paints or evokes the bottle of mustard and
inscribes the words 'Bocquet', 'Bocque' or 'Boc', 'Yvetot' or
'Normande'.[18]

If *Au Chat Botté* and the Dieppois paintings of 1932 are
especially akin to Braque's earlier works, Nicholson was also
looking at the vertical compositions of still lifes on pedestal
tables and mantlepieces which Braque was making in the late
1920s and early 1930s, as can be seen in Nicholson's *Journal
de Rouen 1932*.[19] And he was quick to show interest in the
new work he now saw in Braque's Paris studio.

'I have just seen some lovely Braques', he wrote to Hepworth
at the beginning of January 1933 on his return from a visit
to Braque in Paris: 'he is illustrating some Greek thing &
he had done some decorations on plaster, black with a
scratched white curly endless design – very beautiful – &
closely connected with the idea in your green verdi thing.'[20]
Braque had recently become fascinated with the *Theogony* by
the ancient Greek poet Hesiod, and he had just completed
a series of etchings to illustrate an edition of it.[21] Alongside
these he made the engraved plasters (coated in black paint
and incised to expose the white of the plaster beneath) which
Nicholson describes. A reproduction of one of them, the sea

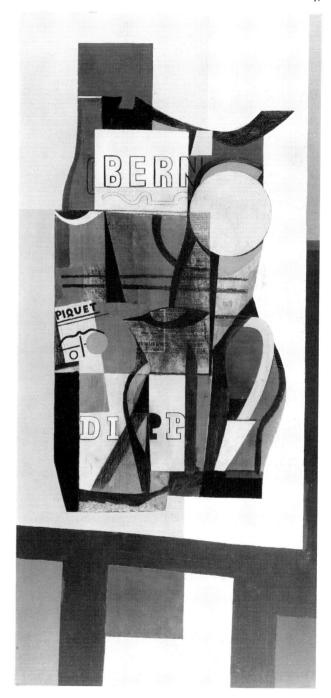

Ben NICHOLSON
Collage, 1933
oil and papers, 100.33 × 45.72 cm
Reproduced by permission of
Angela Verren-Taunt

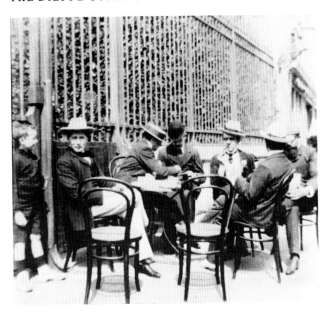

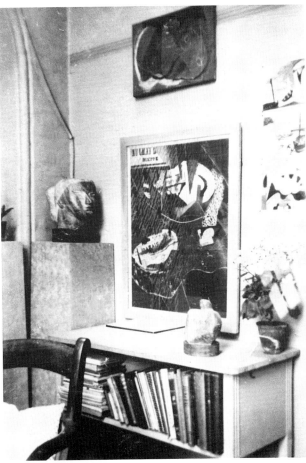

nymph Sao, can be seen in a photograph of Nicholson's studio in 1933.[22] Braque's free and rhythmical linear style surely encouraged Nicholson to develop his own natural pleasure in line for its own sake. His variant on Braque's new idiom is seen in paintings such as *Guitar* 1933 (oil and gesso on canvas; Kettle's Yard, University of Cambridge) and *Coin and musical instruments* 1933, with their lively play of lines incised in dark grounds.[23] The metamorphic possibilities of this lyrical line, which especially appealed to Braque, are given full play by Nicholson in, for example, *Composition in black and white* 1933 (oil and gesso on board; Swindon Art Gallery), a still life on a table top which borrows the sensuous curves of a nude.[24] Nicholson went on to make his own remarkable synthesis of Braque's liberating style with the work of two rather different artists, Joan Miró and Alexander Calder, exemplified in a painting such as *Milk and plain chocolate* 1933.[25] Nicholson's rapid development towards abstraction — in late 1933 he made his first completely abstract relief and the first all-white reliefs soon followed — and the variety of his interests and contacts soon set him apart from Braque.[26] But, as will be seen, all four men were later brought together at Varengeville.

Braque spent the summer of 1928 in Varengeville at the invitation of the American architect Paul Nelson, whose French wife Francine had family connections there. Braque decided to build a house on the edge of the chalk plateau a short distance inland. He asked Nelson to design a resolutely Norman house (much to the architect's frustration) which was completed in 1931.[27] For the rest of his life Braque divided his time between Paris and Varengeville.[28]

Braque's arrival in Varengeville had coincided with his return to landscape painting, abandoned in 1911, and with the first of a little-known group of bathers of which *La Plage* (cat. 13) is an example.[29] The turn of the decade was an experimental period in Braque's work, and his bathers are clearly indebted to Picasso's recent beach scenes. They are creatures out of the *Théogonie*, with close relatives in Braque's Greek warriors and other mythological creatures, transposed to a French beach of the 1930s, complete with the bathing huts which were then a feature of the beach at Varengeville.[30]

La Plage de Dieppe (cat. 12) is one of the first of a group of about thirty-five Normandy seascapes painted by Braque between 1928 and the outbreak of war in 1939.[31] Reproduc-

Dieppe, 1903: (l to r) Ben Nicholson, Gordon Lennox, William Nicholson, (not known), Max Beerbohm

Ben Nicholson's studio, The Mall, 1933, with reproductions of three Braque paintings on the right

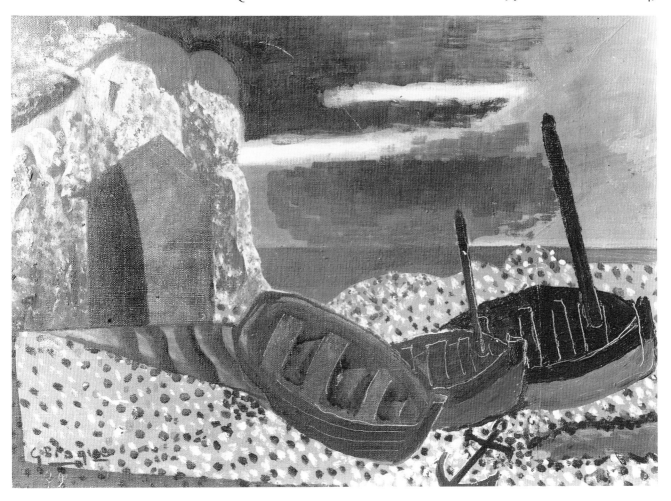

Georges BRAQUE
12. *Dieppe Beach (La Plage de Dieppe)* 1929
oil on canvas, 24 × 36 cm
Moderna Museet, Stockholm. Statens Konstmuseer
© ADAGP, Paris and DACS, London 1992

tions of two can be seen pinned to the wall of Nicholson's studio in 1933 – *La Barque D.27 (The Fishing Boat D.27)* 1929 and *Falaise et Bateaux (Cliff and Boats)* 1930.[32] Variations on the theme of boats beached beneath cliffs, they are unmistakably of their place. And yet these small paintings are also akin to still lifes: Braque tips up the boats like so many objects in a still life.[33] The influence ran both ways, for as the critic Christian Zervos noticed in 1932, contact with the open air in Normandy profited Braque's still lifes, enlivening them with a new sense of rhythm.[34] Revealingly juxtaposed on the pages of Braque's sketchbooks, still lifes and bathers or the occasional marine share the same generative force.[35]

In 1939, using pieces of chalk from the magnificent sculptural cliffs at Varengeville, Braque made a small number of sculptures which he cast in plaster and later bronze.[36] The product of Braque's love of materials, they too derive from the *Théogonie* and are a natural extension of the incised plasters. Picasso and Léger were also connoisseurs of the pebbles on Dieppe's beaches in the 1930s. Nicholson discovered Picasso's interest at their first meeting: 'I was not long at Picasso's before he talked about the pebbles on the beach at Dieppe. . . Dieppe seems to be most of France.'[37] On his walks in the surrounding woods, Braque was also attracted by tree trunks and roots from which he made furniture, such as a lectern and a fine tree chair. Braque's experiments with sculpture attracted the attention of another artist who was living at Varengeville in 1939–40, Joan Miró. Working notes written by Miró in the early 1940s reveal that he learnt much about techniques and materials from Braque.[38]

Miró had first visited Varengeville in the summer of 1937, like Braque at the invitation of Paul Nelson.[39] It was Nelson too who had brought Calder to Varengeville for the first time earlier in the year; Calder in turn invited Nicholson and Hepworth to stay that summer.[40] Thus 1937 found Nicholson together with three of the most significant artists in the develop‑ ment of his work, Braque, Miró and Calder, at the highpoint of Varengeville's history as an artistic centre.

Notes

1. The shop still exists at 95 Grande Rue, though 'Au Chat Botté' survives only in small letters on the window.

2. 'Notes on Abstract Art', *Horizon* (London) vol. IV, no. 22, October 1941.

3. The photograph taken soon after the painting was completed shows that the mysterious guitar has always had a shadowy presence – it has not appeared with age.

4. Such as *Head* (Cumberland alabaster) 1930. Photographs taken by BN at the time often exploit mirror reflections.

5. The Auberge, which has since disappeared, offered rooms and food. Sole à la Dieppoise is served with cream and white wine sauce, mushrooms, shrimps and mussels.

6. It is interesting to compare BN's Dieppe works with the two paintings made by Picasso after a trip with Braque to Le Havre in April 1912 – *Souvenir du Havre* and *Violin, Wineglasses, Pipe and Anchor* – which are full of references to the visit: *Souvenir du Havre* is reproduced in the special Picasso number of *Cahiers d'Art* (Paris) 1932 p. 109, a copy of which can be seen in photographs of the Mall Studio BN shared with BH.

7. BN's inherited love of the still life – derived from his father William – made him particularly receptive to Cubist still life.

8. The model for the small, angled guitar in *Au Chat Botté* can be seen in photographs of the studio. The instrument also appears in BN's *1932 (Guitar)*. BN painted the violin, guitar, mandolin, balalaika. As with Cubist musical paintings, BN's have sometimes come to be known by erroneous titles.

9. BN probably met Braque for the first time in January 1933, and BH met him later the same year. In the spring of 1930 BN's friend Jim Ede, a member of the Tate Gallery staff, had suggested that H.P. Roché, the collector, agent, writer and great introducer, might take BN to Braque. This does not seem to have happened, though in June of that year Roché did show photographs of BN's work to Braque.
 Ede early noted the affinity between BN's work and that of Braque (see his introduction to the catalogue of the exhibition *Paintings by Ben and Winifred Nicholson and Pottery by Staite Murray*, Alex. Reid

and Lefevre Gallery, London, July 1928). Christian Zervos also wrote of the kinship (*Cahiers d'Art* 1930 p. 223).
 BN frequently visited his first wife Winifred and their children in Paris after they moved there in the autumn of 1932. He would often have travelled through Dieppe *en route*. In late 1932 and early 1933 BN and BH seriously considered moving to Paris.

10. The slant of this essay is a consideration of the special nature of the relationship between Braque and BN, but the importance of Picasso to BN cannot be underestimated. BN's first meeting with Picasso was on 15 March 1933 at Picasso's Paris studio. BN returned soon afterwards with BH, who had joined him in France for a holiday in Avignon. It is now clear that this celebrated visit to Avignon, and the visits to the studios of Brancusi and Arp so import‑ ant for BH, were at Easter 1933, not 1932 as has long been thought: BH mistakenly remembered the date as 1932 in her later accounts (see e.g. *Barbara Hepworth. Carvings and Drawings* (London, 1952) opposite plates 16 and 17). The evidence is in the letters and in works by BN such as *Collage with Spanish Postcard* 1933 (in fact a French postcard) and *Collage, 1933*, both of which contain cuttings from the masthead of *Le Petit Provençal* for 17 April 1933.

11. Twelve letters and cards, all but one dating from December 1932 to January 1937, are preserved in the Nicholson Archive. Only two letters, dating from the 1950s, survive from Nicholson to Braque (Archives Laurens).

12. Letters in the Hepworth Archive.

13. See his 'Memoirs: William Nicholson', *London Magazine*, vol. VII, no. 3, June 1967.

14. Early in 1933 BN was eager for there to be a Braque exhibition at Tooth's, and he put Braque and Tooth in touch. In the event, Braque had an exhibition at Alex. Reid and Lefevre, London, in July 1934; BN may have had some part in this since he showed regularly at Lefevre. Works by BN and Braque were exhibited together for the first time at the Mayor Gallery, London, in April 1933 (*Exhibition of Recent Paintings by English, French and German Artists*). Braque visited London in both 1933 and 1934. Geoffrey Grigson remembered BN driving Braque along Keats Grove, Hampstead (see *Ben Nicholson: A Studio International special*, edited by Maurice de Sausmarez (London and New York, 1969) p. 14).

15. The mistake about this visit is made in e.g. Charles Harrison *English Art and Modernism 1900–1939* (London and Bloomington, Indiana, 1981) p. 255. He also confuses the 1937 visit – Miró and Calder were not in Varengeville until 1937. BN and BH probably stopped off to see Braque in Varengeville on their way home from Paris and Avignon in April 1933. Plans for another visit to Braque at Varengeville in mid September 1933 are discussed in letters between them.

16. Braque had pioneered the introduction of new materials such as gesso and sand in 1912 and he continued to make much use of them. BN began to use gesso in the late 1920s.

17. The newspaper cuttings BN makes use of in this collage and

in several related paintings enable one to suggest that the 1932 visit to Dieppe probably took place around 5–8 August. In *January 27 1933* Nicholson glues on a portion of the front page of *Le Quotidien* for 6 August and of *Le Journal* for 8 August. One of the fish is made of the word 'RABAIS' (reduction) in an advertisement for a clothes sale which appeared in e.g. the 5 August issue. Then in the 1932 oil, *Le Quotidien* (Tate Gallery), he paints his own version of the same 6 August *Quotidien* masthead and headlines. Finally, the masthead of *Le Journal* for 8 August and a reference to the tennis player Cochet and 'La Coupe Davis' accompany the *Fishes, 1932*.

18. See *Still life (Bocquet)* 1932 (oil on wooden signboard) and *1932–35 (BOC)* (oil on board). The curly flourishes above the letters in the Arts Council painting are derived from the scrolls on the label of the bottle, as can be seen in these related works. BN kept one of these distinctively shaped squat bottles of Bocquet (as seen in *BOC*) in his collection of still-life objects, for it is later included in a pencil drawing, *1946 (Still life, Porthmeor)* and in *April 1950 (bocquet)*. Perhaps he intended a pun on *bocal*, a wide-mouthed, short-necked bottle or jar. Or even, in *BOC*, on *le Bocage Normand*, a wooded area of Normandy.

19. Part of the masthead of the *Journal de Rouen* is also used in *Two fishes (Rouen)* 1932.

20. The sculpture is probably the green marble *Profile* of 1932. It is an example of Hepworth's use at this time of linear incisions in her sculptures, which have a close affinity with BN's contemporary work. Sharing a studio with BH also stimulated BN in his sculptural explorations.

21. Commissioned by Vollard, their publication was delayed by his death in 1939. *Théogonie* was finally published in 1955 by Maeght.

22. Stanislas Fumet *Sculptures de Braque* (Paris, 1951) plate 26. Sao was also one of the *Théogonie* etchings (see Dora Vallier *Braque. The Complete Graphics. Catalogue Raisonné* (New York and London, 1982) p. 49). Related drawings are published in *G. Braque et la Mythologie* (Galerie Louise Leiris, Paris, 1982) p. 40. Compare also, for example, the head of *Sao* (Fumet plate 21) with BN's *St Rémy*. The humorous quality of these works would have appealed to BN.

23. In *Guitar* and other paintings of this group, BN uses gesso (a prepared surface of plaster) as a ground for painting, comparable to Braque's plaster engravings. See also note 16. BN had begun to incise lines into paint in the 1920s: *Auberge* is a later example. He had made linocuts too from 1926. Braque's use of a scratched line is most notable in a series of paintings contemporary with the *Théogonie* etchings, such as *Grande Nature Morte Brune* 1932, characterized by incised or thinly painted white lines.

24. The even more equivocal *Painting 1932* (Tate Gallery) can be read as a still life, a reclining nude and a landscape. 1933 is surely a more probable date for this painting. In a nearly finished state it can be seen in a photograph of the studio taken in 1933.

25. Picasso should also be mentioned, especially his 1924 dot-and-line drawings which BN loved. Picasso also had his own incised linear style, and his 1923–6 paintings of still lifes of musical instruments must have been known to Braque.

BN later characterized *Guitar* 1933 (Tate Gallery) and *Still life (Mediterranean)* 1933 as 'surrealist' (letter to John Summerson, 1 February 1944, Tate Gallery Archive), but his 'Surrealism' did not include any interest in Surrealist theories of automatism. The letter of 9 August 1936 from Miró to BN suggests that there was a friendly but not close relationship between them. It was Miró's dream paintings of 1925–7 which made the deepest impression on BN. The abstract wire stabiles and mobiles by Miró's close friend Calder were also very important to BN at this time.

26. Braque had a lifelong antipathy to abstract art, though the craftsmanship of BN's abstract reliefs would have appealed to Braque the artisan. In retrospect BN found the imaginative idea of *Au Chat Botté* analogous to that of one of his abstract reliefs ('Notes on Abstract Art', op. cit.).

27. See Nelson's 'Mon Ami Braque', *Les Lettres françaises* (Paris) 6–12 September 1962 and the interview with Nelson published in *Perspecta (The Yale Architectural Journal)*, (New Haven) nos 13/14, 1971.

28. He would arrive for the summer and frequently stay late into the year, spending Christmas there too.

29. One or two Provençal landscapes of 1926–7 are the prelude to these Varengeville seascapes. There are three distinct types of bathers: for the first two see *Catalogue de l'Oeuvre de Georges Braque. Peintures 1928–1935*, Maeght Editeur (Paris, 1962) pp. 21, 41, 63, and pp. 41, 60, 61. *La Plage* (cat. 13) is an example of the third series; see the related pair of paintings on p. 62, and also *La Plage*, illustrated in Galerie Louise Leiris, op. cit., p. 66.

30. Contemporary postcards show the bathing huts. The right-hand bather in the painting is closely related to the *Théogonie* etching of Gaia, see *Complete Graphics*, op. cit., p. 52. There is also an engraved plaster of 1939. Related drawings are reproduced in Galerie Louise Leiris, op. cit., p. 44. The *Théogonie* was a controlling influence on Braque's work for the rest of his life.

31. Some are very slight works. Braque liked to work on various paintings at the same time, rolling up the canvases in progress and taking them with him when he travelled between Paris and Varengeville.

32. They are, respectively, Maeght, op. cit., p. 36 (sold at Sotheby's London, 3 July 1979) and Maeght p. 57. Alongside them is *La Nappe Rouge* 1931 (Maeght p. 64), one of an important series of still lifes on coloured tablecloths.

33. The cliffs themselves encourage metamorphic interpretations: one Dieppe cliff is known as 'la Grosse Femme'.

34. *Cahiers d'Art* 1932 pp. 19–20.

35. Archives Laurens. These bathers and marines are found among the extraordinary profusion of drawings related to the *Théogonie* in Braque's sketchbooks.

36. His friend the médailleur Fernand Buzon helped him to cast the sculptures in plaster.

37. Letter to BH. Dieppe acquired something of a reputation in the 1930s as the beach to visit for collecting stones and debris (it was the most accessible beach from Paris). On Sundays between 1933 and 1938, Léger, Pierre Jeanneret and Charlotte Perriand would often make expeditions there to gather and photograph stones, bones and other suggestive objects.

38. See Joan Miró *Selected Writings and Interviews*, edited by Margit Rowell (London, 1987) pp. 168, 181–2, 195. This evidence contradicts Jacques Dupin's belief that, despite the very friendly relations between Braque and Miró, neither moved an inch (*Joan Miró* (Paris, 1961) p. 306).

39. The evidence for this 1937 visit, unnoticed in writing on Miró, is from Calder, *An Autobiography with Pictures* (London, 1967) p. 163; also a postcard from Calder to BN and BH, 4 July 1937; and Hepworth's account of the holiday in *Barbara Hepworth 1952* op. cit., facing plate 37. The photograph illustrated in *Perspecta* op. cit., p. 77 of Nelson, Calder and Miró on the beach at Varengeville must date from 1937. Also illustrated there is a photograph of Kandinsky, Magnelli, Zervos and others outside Nelson's Varengeville house, probably in 1939.

Nelson lent Miró his house in the summer of 1938, and Miró painted a mural there, *Birth of the Dolphin*. In August 1939 Miró rented a villa at Varengeville, the Clos des Sansonnets, where he stayed until May 1940. During this period of intense productivity Miró began the famous series of 'Constellations' gouaches.

Paul Nelson (1895–1979) was a Chicago architect who lived and worked much in France. Between 1936 and 1938 he was engaged on a research project for a *maison suspendue*, of which painting and sculpture were an integral part. Nelson's artist-friends Arp, Miró and Léger collaborated on the first maquette (now lost) and Calder, Miró and Léger contributed to the second (Museum of Modern Art, New York). See Nelson's *La Maison Suspendue* (Paris, 1939). BN himself received a commission from Nelson for an unrealized project – the linocut *Abstract with Red Circle* (1938) relates to this commission.

Nelson's other guests in the summer of 1937 included Léger in July. See Fernand Léger *Lettres à Simone* (Paris, 1987) p. 212.

40. The Calders rented a small house, the Clos du Timbre, near Nelson's. See Calder's *Autobiography*, op. cit., pp. 155–164. Calder also invited John and Myfanwy Piper (their visit is mistakenly dated 1935 in *John Piper* (Tate Gallery, London, 1983) p. 42).

[Some of the archive material referred to in this essay has been provided by Alan Bowness, who is cataloguing the Nicholson Archive at the Tate Gallery and writing the life of Barbara Hepworth. I am particularly grateful to Monsieur and Madame Claude Laurens for their assistance with information about Braque.]

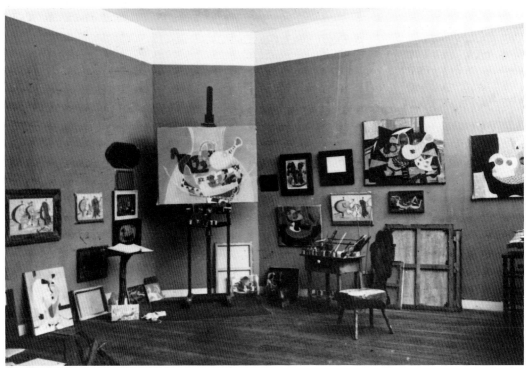

Georges Braque's studio at Varengeville *c.* 1934
Photo M. & Mme C. Laurens

Catalogue

Measurements are given in centimetres, height before width. q.v. indicates a cross reference. Notes by Sophie Bowness.

Aubrey BEARDSLEY (1872–98)
British
1. *The Bathers*, plate cut from the *Savoy* No. 1, January 1896 (edited by Arthur Symons and published by Leonard Smithers) The Board of Trustees of the Victoria and Albert Museum (ill. p. 39)

Beardsley was in Dieppe in August 1895 and again in September/October. There he planned the first issue of the magazine the *Savoy* with its editor Arthur Symons. He worked on his 'romantic novel' *Under the Hill* (a version of the Venus and Tannhäuser legend), and a poem with illustrations, 'The Three Musicians'. Both were published in the *Savoy*. Symons's essay 'Dieppe: 1895' also appeared there, illustrated with *The Bathers* and *The Moska* by Beardsley. (The Moska was a dance at the children's ball in the Dieppe Casino.) Beardsley's fabled lack of interest in his surroundings is belied by the Dieppois pebbles which he draws in *The Bathers*.

Beardsley grew to love Dieppe and returned for the last time in the summer of 1897.

Jacques-Emile Blanche painted both Beardsley and Symons during the summer of 1895. The *Portrait of Aubrey Beardsley* against a coastal background (cat. 4) displays the enthusiasm for eighteenth-century art which Blanche and Beardsley shared. Symons was a key interpreter of contemporary French literature in England. His poems about Dieppe included one dedicated to Sickert called a 'colour study', dated 16 September 1893.

Max BEERBOHM (1872–1956)
British
2. *Aubrey Beardsley* c. 1894
pen and ink on paper, 27.8 × 23.2 cm
The Visitors of the Ashmolean Museum, Oxford (ill. p. 37)

3. *Oscar Wilde* 1894
pen and ink on paper, 30.9 × 19.2 cm
The Visitors of the Ashmolean Museum, Oxford (ill. p. 37)

The writer and caricaturist was a friend and exact contemporary of Aubrey Beardsley. He drew Beardsley a dozen times, and summarized Beardsley's work in an admiring review, 'Mr. Beardsley's Fifty Drawings' of 1897. Beerbohm's first published article was on Wilde, and he often drew him. The drawing of Wilde shown here was published in *Pick-Me-Up* (22 September 1894).

Beerbohm loved Dieppe and was a frequent visitor. In the summer of 1900 Sickert recommended that he stay at the pension Lefèvre in the rue de l'Hôtel de Ville, which Whistler also patronized. Beerbohm was in Dieppe again in 1901, when he dined with Pissarro (q.v.). In the summers of 1903, 1905 and 1907 he was joined by friends such as Marie Tempest, Cosmo Gordon-Lennox, Constance Collier and William Nicholson (q.v.).

Beerbohm did a humorous two-part self-portrait drawing comparing his behaviour in London and Dieppe. (It is illustrated in J-E. Blanche's *Portraits of a Lifetime* (London, 1937) facing p. 272.) His caricatures of Blanche include one in which Blanche, dressed in top hat and tails, beats a drum and shouts 'SICKERT' through a megaphone (British Museum, Department of Prints and Drawings).

Jacques-Emile BLANCHE (1861–1942)
French
4. *Portrait of Aubrey Beardsley* 1895
oil on canvas, 90.2 × 71.7 cm
National Portrait Gallery, London (ill. p. 37)

5. *Plage de Dieppe en août* [1896]
oil on canvas, 60.5 × 73 cm
Musée des Beaux-Arts, Rouen (ill. p. 54)

6. *Portrait of Walter Sickert* 1898
oil on canvas, 79.5 × 64.8 cm
National Portrait Gallery, London (ill. p. 34)

7. *The Front at Dieppe* 1908
oil on canvas, 40 × 58 cm
Mark Cherniavsky

8. *Arrivée du Hareng*
oil on canvas, 42.5 × 55 cm
Musée des Beaux-Arts, Rouen

9. *Baigneurs à Dieppe c.* 1935
oil on canvas, 97 × 129.5 cm
Château-Musée de Dieppe

The fashionable French portrait-painter knew many of the artists represented in this exhibition. The very wide range of his friendships, combined with his knowledge and love of England, contributed significantly towards making Dieppe a centre of Anglo-French artistic life, and his historical importance lies here rather than in his painting. Writers and artists, among them Degas, Renoir, Helleu, Pissarro, Monet, Whistler, Sickert, Conder and Beardsley, gathered at his family's house Bas-Fort Blanc or at his adjoining studio. He later moved outside Dieppe to Offranville. His autobiographical writings such as *Portraits of a Lifetime* (1937) and *La Pêche aux Souvenirs* (1949) are an invaluable source of information about Dieppe. His book *Dieppe* (1927) was dedicated to Sickert (q.v.), whom he saw in retrospect as one of the cardinal points of his life. They met in London in 1885. Blanche gave Sickert very valuable support, notably by buying a remarkable number of his paintings. The two friends shared what was effectively dual nationality, dividing their lives between France and England. Blanche painted Sickert's portrait on several occasions (see cat. 6) and Sickert's painting of Blanche is also exhibited here (cat. 79).

The portrait of Marie Tempest made by J-E. Blanche in 1903 may have been done in Dieppe (now in the Garrick Club, London). Her husband, Cosmo Gordon-Lennox, wrote a skit with Harry Melville called 'A Painting Class as Boarding House', based on incidents which took

Jacques-Emile BLANCHE
5. *Dieppe Beach in August (Plage de Dieppe en août)* [1896]
oil on canvas, 60.5 × 73 cm
inv. 932 1.4
Musée des Beaux-Arts, Rouen. © DACS 1992

place in Blanche's Dieppe studio.

Blanche painted Dieppe subjects, such as the beach and harbour, throughout his life (cats 5, 7, 8, 9).

(See also Renoir, Beardsley, Beerbohm and William Nicholson.)

Richard Parkes BONINGTON (1802–28)
British
10. *Pays de Caux: Twilight* 1823
oil on canvas, 31.1 × 41 cm
Manchester City Art Galleries (ill. p. 17)

Bonington spent much of his short adult life in France. He shared a studio in Paris with Delacroix in 1825–6. He travelled widely and made sketching tours of Normandy. In the summers of 1823 and 1824 he was in the Pays de Caux, the chalk plateau of Upper Normandy which ends in magnificent cliffs on both sides of Dieppe. *Pays de*

Caux: Twilight is thought to have been painted after a pencil sketch made on the 1823 trip. Among related works is the watercolour made at the end of his life, *Sunset in the Pays de Caux* (1828; Wallace Collection, London).

Bonington lithographs were used for the second Normandy volume of Baron Taylor's *Voyages Pittoresques et Romantiques dans l'Ancienne France* (1825).

Constantin B R A N C U S I (1876–1957)
Romanian (naturalized French)
11. *The Kiss with collage* 1925
pencil, pen and cigarette card on paper,
17.5 × 24.7 cm
Private Collection (ill. p. 55)

This drawing was given to Cordelia
Dobson by Brancusi on his visit to London
in the autumn of 1925 for the 'Exhibition
of Tri-National Art: American, French
and English' at the New Chenil Gallery.
Cordelia's husband, the sculptor Frank
Dobson, was also among the exhibitors.
The pencil drawing of the Kiss (a theme to
which Brancusi was devoted for nearly forty
years) is juxtaposed with a cigarette card
representing an early coat of arms granted
Dieppe (two mermaids, an angel and an
escutcheon bearing a ship against a half red,
half blue background which symbolizes
England and France), on which he has
written: 'Heureusement que c'est un ange
entre les deux sirènes car si sera moi je me
serai fichu' ('Luckily it's an angel between
the two sirens because if it were me I'd be

Constantin B R A N C U S I
11. *The Kiss with collage* 1925
pencil, pen and cigarette card on paper,
17.5 × 24.7 cm
Private Collection
© A D A G P, Paris and D A C S, London 1992

flat out'). Brancusi perhaps intended a play-
ful recasting of the Kiss in terms of Anglo-
French relationships. No explanation has
yet been offered for the cryptic inscription
which borders the drawing of the Kiss.
(Compare the drawing sent to Tarsila do
Amaral and Oswaldo de Andrade in 1926,
illustrated in Sidney Geist, *Brancusi: The
Kiss* (New York, 1978) p. 67.)

Georges B R A Q U E (1882–1963)
French
12. *Dieppe Beach* (*La Plage de Dieppe*) 1929
oil on canvas, 24 × 36 cm
Moderna Museet, Stockholm (ill. p. 49)

13. *The Beach* (*La Plage*) 1932
oil on canvas, 30.5 × 41 cm
Collection M. et Mme Claude Laurens (ill.
p. 77)

Braque's family moved to Le Havre from
Argenteuil when he was a boy and he
returned to the Normandy of his youth in
the late 1920s. He had a house built for
himself at Varengeville where for the rest of
his life he spent part of each year. His visits
to Varengeville coincided with a return to
landscape painting: *Dieppe Beach* is one of
the first of this series of about thirty-five
seascapes which he painted in the years up
to the outbreak of World War II. These
were complemented by a group of paintings
of figures on the beach dating from the late

1920s and early 1930s, such as *The Beach*,
which relate to the work he was then doing
to illustrate Hesiod's *Théogonie*. In 1939
Braque used pieces of the local chalk to
carve sculptures, casting them in plaster and
later in bronze. The Normandy paintings
made in the last years of his life – seascapes
and landscapes of the Pays de Caux –
include some remarkable works. He is
buried at Varengeville.

Félix C A L S (1810–80)
French
14. *Cliffs near Dieppe* (*Falaises près Dieppe*)
1862
oil on canvas, 20.7 × 31.7 cm
The Syndics of the Fitzwilliam Museum,
Cambridge (ill. p. 11)

This small study from nature dated Septem-
ber 1862 was formerly in the collection of
Cals's great patron, the Comte Doria, in
whose château Cals was then living. It is
related to two similarly sized paintings and
at least one pen-and-ink drawing, all of the
cliffs near Puys, just north of Dieppe. It
makes an interesting comparison with
Monet's later paintings of the cliffs on the
other side of Dieppe, especially those of
1882. Cals also painted at Pourville during
this visit.

 Cals was associated with the circle of
Jongkind and in the 1870s he settled in
Honfleur. In this decade he took part in the
first Impressionist exhibitions, without him-
self necessarily sharing Impressionist aims.

Charles C O N D E R (1868–1909)
British
15. *Dieppe* 1895
oil on canvas, 33.2 × 46.5 cm
Manchester City Art Galleries (ill. p. 68)

16. *Beach Scene, Dieppe* 1895
oil on canvas, 33 × 44.5 cm
Sheffield City Art Galleries (ill. p. 31)

Born in London, Conder studied painting
in Australia and subsequently in Paris,
where he was a friend of Toulouse-Lautrec.
He was based in London from the mid
1890s and was a frequent visitor to Dieppe
in this decade. His circle there included
Blanche, Thaulow, Beardsley, Symons and
Wilde. He made a group of paintings of the
front, beach and cliffs. The two shown here

were painted during the summer Conder spent in Dieppe in 1895. He wrote from there to his friend William Rothenstein: 'you would simply love Dieppe. . . There has been a whole new existence here. . . The whole front of the sea is simply magnificent' (quoted in John Rothenstein, *The Life and Death of Conder* (London, 1938) pp. 123–4). Conder liked Dieppe so much that he even considered settling there. (See also William Rothenstein.)

John Sell COTMAN (1782–1842)
British
17. *Saint Jacques Façade* 1818
pencil and wash on paper, 29.2 × 23.2 cm
Birmingham Museums and Art Gallery
(ill. p. 56)

18. *Dieppe Harbour* 1823
watercolour on paper, 28.7 × 53.2 cm
The Board of Trustees of the Victoria and Albert Museum (ill. p. 84)

Cotman arrived in Dieppe in June 1817 to begin a tour of Normandy which was his first visit abroad. He returned the following year. On both occasions he made pencil sketches from the motif as he travelled, such as *Saint Jacques Façade* (cat. 17). The watercolour panorama of Dieppe from the eastern cliffs (cat. 18) was done some years later in 1823. Etchings of Saint Jacques and the castles of Dieppe and Arques are among the hundred made for *The Architectural Antiquities of Normandy* (1821).

Charles-François DAUBIGNY (1817–78)
French
19. *Dieppe Harbour (Le Port de Dieppe)* c. 1876–7
oil on panel, 39 × 67 cm
Noortman (London) Ltd (ill. p. 19)

Daubigny, one of the landscape painters of the Barbizon school, was a pioneer of working in the open air. The example of his painting, fresh and lacking in traditional finish, was of considerable importance to his young friend Monet and to other Impressionists. In the summer of 1876 Daubigny was at Arques and Dieppe, where he met fellow-painters Antoine Vollon and Gustave Guillaumet.

Closely related to *Dieppe Harbour* (cat. 19) is a *View of Dieppe* painted from a similar

John Sell COTMAN
17. *Saint Jacques Façade* 1818
pencil and wash on paper, 29.2 × 23.2 cm
Birmingham Museums and Art Gallery

viewpoint (illustrated in E. Moreau-Nelaton, *Daubigny Raconté par Lui-Même* (Paris, 1925) figure 99, dimensions unknown). Daubigny also painted the town from the Bassin Bérigny to the south (*Dieppe* 1877, 67 × 101 cm, Frick Collection, New York). He sent one of these works – it is not known which – to the Salon of 1877, the last he took part in before

his death. All three were painted from studies made on the 1876 visit to Dieppe and in all the church of Saint Jacques is the central point.

Twenty years after Daubigny's *Dieppe Harbour*, Boudin painted a comparable view (reproduced in Robert Schmit, *Eugène Boudin 1824–1898* (Paris, 1973) vol. 3, no. 3055).

A view of the *Vallée de l'Arques* (c. 1876) is in the Musée d'Orsay – river valleys were a favourite subject of Daubigny's.

A painting by his son Karl of the *Vallée de la Scie, près de Dieppe* (1875) is also in the Musée d'Orsay.

Eugène DELACROIX (1798–1863)
French
20. *The Sea at Dieppe (La mer, vue des hauteurs de Dieppe)* c. 1852
oil on wood panel, 35 × 51 cm
Musée du Louvre, Département des Peintures (ill. p. 19)

Delacroix made five visits to Dieppe between 1851 and 1860. His journal entries during these visits movingly reveal his fascination for the sea (see especially 25 August and 17 September 1854). *The Sea at Dieppe* is often associated with the entry for 14 September 1852: 'Towards three o'clock I went down to take my last look at the sea. It was perfectly calm and I have seldom seen it more lovely; I could hardly bear to tear myself away. . . The sketch I made from memory was of this sea: golden sky, boats waiting for the tide to return to harbour.' (Translated in *The Journal of Eugène Delacroix* (London, 1951).) *The Sea at Dieppe* is remarkable for its anticipation of Impressionist technique and subject matter. Monet in fact owned a related watercolour, *Cliffs near Dieppe* (c. 1852), now in the Musée Marmottan, Paris. Three other marine watercolours are in private collections in Paris and Zurich, and in the Albertina, Vienna; and there are several pages of drawings in a sketchbook in the Rijksmuseum, Amsterdam.

In his journal entry for 20 July 1860 Delacroix describes having seen from the jetty at sunset all the effects he needed for *Christ walking on the Waters*, a painting which was left unfinished on his death.

John Duncan FERGUSSON (1874–1961)
British
21. *Dieppe, 14 July 1905: Night* 1905
oil on canvas, 76.8 × 76.8 cm
Scottish National Gallery of Modern Art, Edinburgh (ill. p. 69)

Born in Scotland, J.D. Fergusson was a regular visitor to France from the mid 1890s, and was resident there for long periods after 1907. *Dieppe, 14 July 1905* derives from one such visit. It is an original recasting of Whistler's famous firework paintings of the 1870s, which Fergusson had probably seen at the Whistler memorial

exhibition in Paris in May 1905. The painter S.J. Peploe is among the figures in the foreground. The work was shown at the Salon d'Automne in Paris in 1907.

Emile-Othon FRIESZ (1879–1949)
French
22. *Dieppe Harbour (Le Port de Dieppe)* 1930
oil on canvas, 53.5 × 63.5 cm
Musée National d'Art Moderne, Centre Georges Pompidou, Paris (ill. p. 57)

Born in Le Havre, Friesz was associated with Fauvism between 1905 and 1907. In later years he frequently painted on the coast of his native Normandy, and was in Dieppe in 1930 and 1931. *Dieppe Harbour* was bought by the French Government from the Salon des Tuileries in 1931 and allotted to the national collection of modern art.

Emile-Othon FRIESZ
22. *Dieppe Harbour (Le Port de Dieppe)* 1930
oil on canvas, 53.5 × 63.5 cm
Musée National d'Art Moderne, Centre Georges Pompidou, Paris
© ADAGP, Paris and DACS, London 1992

Paul GAUGUIN (1848–1903)
French
23. *Harbour Scene, Dieppe (Le Port de Dieppe)* 1885
oil on canvas, 60.2 × 72.3 cm
Manchester City Art Galleries (ill. p. 21)

Gauguin was in Dieppe from July to October of 1885, with a short trip to London in August-September. He painted four known works – *The Beach at Dieppe* (Ny Carlsberg Glyptotek, Copenhagen), *Bathers at Dieppe* (National Museum of Western Art, Tokyo), *Ships in Port* and *Harbour Scene, Dieppe*, exhibited here. This was painted from the end of the Quai Henri IV, just east of where the cross-Channel boats dock, looking across the harbour to Le Pollet (shortly before the swing bridge was built). In his writings of the time Gauguin was beginning to formulate the ideas which would lead him beyond Impressionism, but this painting is clearly still indebted to his mentor, Pissarro.

Gauguin's time in Dieppe in 1885 overlapped with Whistler's and he may perhaps have heard Whistler give his 'Ten

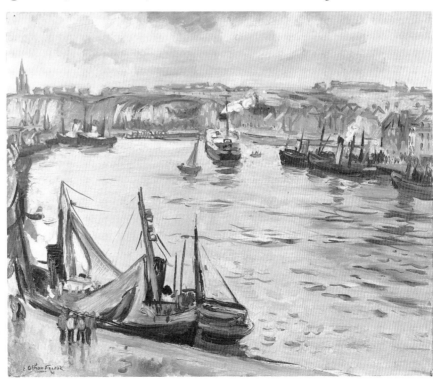

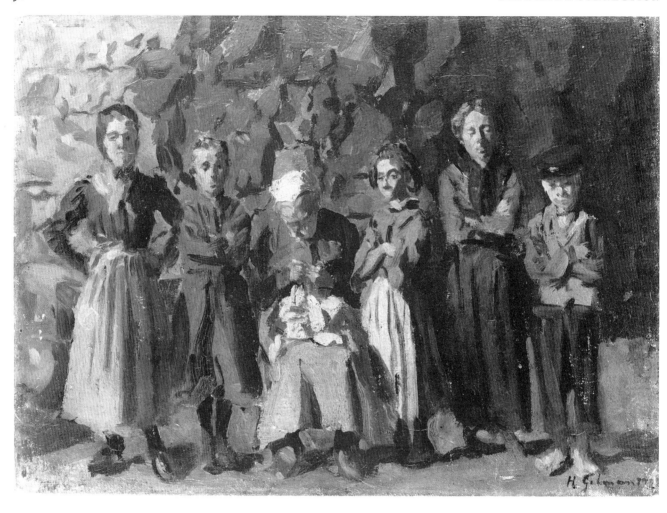

Harold GILMAN
24. *Cave Dwellers, Dieppe* 1907
oil on canvas, 25 × 36 cm
The Visitors of the Ashmolean Museum, Oxford

O'Clock' lecture there. He also saw and
quarrelled with Degas. J.-E. Blanche
remembered seeing Gauguin pass under his
windows at Bas-Fort Blanc on his way to
paint the fishing grounds by the rocks.
Pissarro later showed Blanche what years
after he recalled as a 'small canvas of the
fishing grounds': this seems to refer to a lost
work by Gauguin, or just possibly to the
Copenhagen painting (but this is over
70 × 70 cm) which includes the nets.
(Monet had already painted these distinctive

standing nets in 1882.) Blanche detected in
Gauguin all the signs of megalomania
(curious physiognomy, extravagant dress,
haggard look) as defined by his father Dr
Blanche, the noted alienist (*Propos de Peintre.
De Gauguin à la Revue Nègre* (Paris, 1928)
pp. 5–6).

Harold GILMAN (1876–1919)
British
24. *Cave Dwellers, Dieppe* 1907
oil on canvas, 25 × 36 cm
The Visitors of the Ashmolean Museum,
Oxford (ill. p. 58)

25. *In Sickert's House, Neuville* c. 1907
oil on canvas, 59.7 × 54.7 cm
Leeds City Art Galleries (ill. p. 15)

26. *The Swing Bridge, Dieppe* (*Le Pont
Tournant, Dieppe*) 1911
oil on canvas, 30.5 × 40.6 cm
Private Collection (ill. p. 72)

27. *Dieppe* 1911
oil on canvas, 61 × 76.2 cm
Save and Prosper Group Limited (ill. p. 59)

Sickert lent Gilman his house at Neuville
on the outskirts of Dieppe in the summer
of 1907, and Gilman may have spent nearly
a year in Dieppe. The interior (cat. 25)
probably represents Sickert's house. The
uncharacteristic painting, *Cave Dwellers,
Dieppe* (cat. 24), of a group of the poor
troglodytes who lived in the caves in the
cliffs, perhaps derives from contemporary
postcards of the subject which show similar

rows of forlorn figures.

Gilman was a founder-member of both the Fitzroy Street Group (in 1907) and the Camden Town Group (in 1911). He made a decisive visit to Paris with Ginner and the critic Frank Rutter in late 1910 or early 1911, looking particularly at Post-Impressionist painting. Gilman returned to Dieppe in 1911 with Ginner to visit Sickert. *The Swing Bridge* (cat. 26) and *Dieppe* (cat. 27) were painted then with the broken brushstrokes and pure, light colours he had begun to favour. The large view of *Dieppe* is comparable with the panoramas

Harold GILMAN
27. *Dieppe* 1911
oil on canvas, 61 × 76.2 cm
Save and Prosper Group Limited
Photo John Cass

Ginner made on the same visit (*Sunlit Quay*; cat. 28) and with Gore's 1906 panoramas (cats 32, 33). By contrast with these panoramas by Gilman, Ginner and Gore, Sickert preferred a more exclusive, lower viewpoint of the subject.

The Swing Bridge was given by the Camden Town Group to Sickert on the occasion of his second marriage in 1911.

Charles GINNER (1878–1952)
British
28. *The Sunlit Quay, Dieppe* 1911
oil on canvas, 64 × 46 cm
Trustees of the National Museums and Galleries on Merseyside (Walker Art Gallery) (ill. p. 60)

29. *Dieppe Quay* 1911
oil on canvas, 26.5 × 18.3 cm
Sheffield City Art Galleries

30. *La Vieille Balayeuse, Dieppe* 1913
oil on canvas, 61 × 46 cm
Natalie Bevan (ill. p. 27)

Born in France, Ginner studied in Paris. He was close to Gore and especially Gilman, and was a founder-member of the Camden Town Group, to which he brought an Anglo-French perspective. Of the paintings made by Ginner on his visit to Dieppe in 1911 with Gilman, *The Sunlit Quay* (cat. 28) and *Evening, Dieppe* (private collection) form a pair, together presenting a continuous panorama of Dieppe in contrastingly evocative lights. They were both shown at the second Camden Town Group exhibition in December 1911, as was a third Dieppe work, *The Wet Street*. *The Sunlit Quay* was also shown at the Brighton Art Gallery in 1913–14 in the

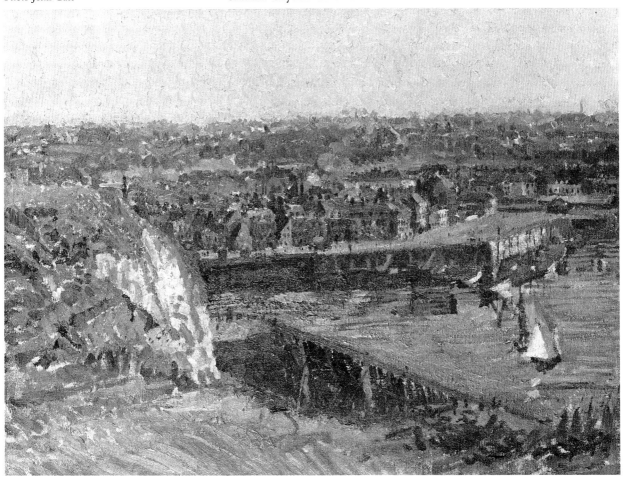

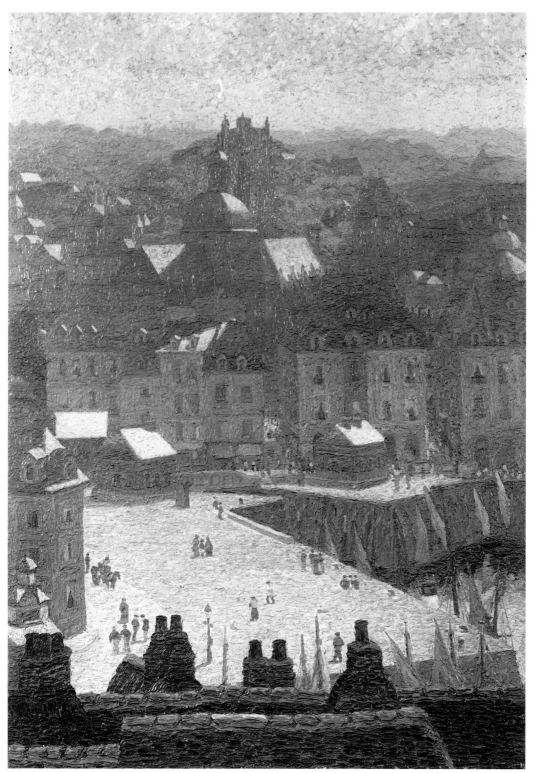

Charles GINNER
28. *The Sunlit Quay, Dieppe*
1911
oil on canvas, 64 × 46 cm
Trustees of the National
Museums and Galleries on
Merseyside (Walker Art
Gallery)
Photo John Mills
(Photography) Ltd,
Liverpool

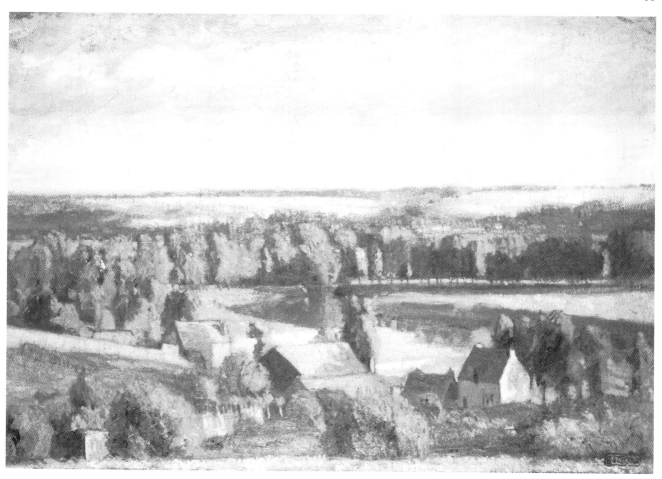

Spencer GORE
31. *Landscape, Dieppe* 1906
oil on canvas, 46 × 66 cm
Private Collection
Photo John Cass

important exhibition of 'English Post
Impressionists, Cubists and others' organ/
ized by the Camden Town Group. So too
was *La Vieille Balayeuse, Dieppe* (cat. 30),
which dates from a visit in 1913.

Spencer GORE (1878–1914)
British
31. *Landscape, Dieppe* 1906
oil on canvas, 46 × 66 cm
Private Collection (ill. p. 61)

32. *View of Dieppe* 1906
oil on canvas, 24 × 32 cm
Private Collection (ill. p. 28)

33. *View of Dieppe* 1906
oil on canvas, 24 × 32 cm
Private Collection

Gore studied at the Slade where Gilman
was a contemporary. He helped to found
both the Fitzroy Street and Camden Town
Groups. It was Sickert's meeting with Gore
in Dieppe in 1904 that persuaded Sickert to
return to London the following year. They
developed a close association which profited
the work of both men. Sickert lent Gore his
house at Neuville in the summer of 1906
and joined him for several weeks. During
this stay, Gore painted about twenty works
of Dieppe and its surroundings. The less
sketchy of the pair of small open/air works,
entitled *View of Dieppe* (Gore no. 18; cat.
32) is a study for the painting, *View of
Dieppe/Vue du Pollet*; 63.5 × 76.2 cm;

(private collection). Hubert Wellington,
who was with Gore and painted his own
related panorama, *Dieppe Harbour*, later
recalled that in Dieppe Gore 'learned from
Sickert the value of working from small,
well/documented drawings' in the prepara/
tion of his paintings ('With Sickert at
Dieppe', *The Listener* 23 December 1954).
The brightly coloured *Landscape, Dieppe*
(cat. 31) relates less to Sickert than to
Impressionism and, in its composition, to
Dutch seventeenth/century landscape
painting.

Sylvia GOSSE (1881–1968)
British
34. *Place Duquesne, Bastille Day c.* 1918
oil on canvas, 61 × 30 cm
Michael Parkin Gallery, London

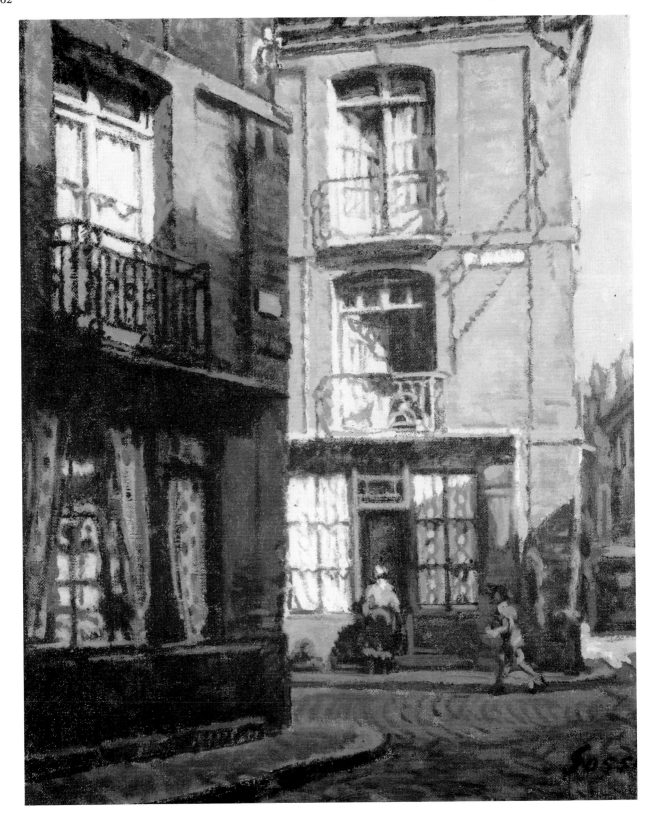

35. *The Market Place, Dieppe* 1920
oil on canvas, 76 × 101.5 cm
Michael Parkin Gallery, London

36. *Rue Cousin, Dieppe* 1938
oil on canvas, 58.5 × 48.25 cm
Michael Parkin Gallery, London (ill. p. 62)

37. *Homeward Bound, la rue Saint-Rémy, Dieppe*
oil on canvas, 59.6 × 49.4 cm
Sheffield City Art Galleries

A pupil and supporter of Sickert, Gosse taught at his school, Rowlandson House, in London. She was one of the first women members of the London Group in 1914. She had a house close to Sickert's at Envermeu, a village inland from Dieppe. Her paintings and etchings of Dieppe were largely made in the 1920s and are modelled on Sickert.

Paul HELLEU (1859–1927)
French
38. *Dieppe Beach (Plage à Dieppe)* 1885
oil on canvas, 50 × 60.5 cm
Musée des Beaux-Arts, Rouen (ill. p. 30)

A fashionable portraitist working in pastel and drypoint, Helleu also liked to paint beside the sea. His work bears comparison with that of his friends Blanche, Sargent and Monet, and *Dieppe Beach* shows the influence of Whistler. His many drypoints include a portrait of his elder daughter, *Ellen à Dieppe* (c. 1900).

From the 1890s Helleu was a close friend of Proust and he was one of the models for Elstir in *A la recherche du temps perdu*.

Pierre HODÉ (1889–1942)
French
39. *Dieppe Harbour (Le Port de Dieppe)*
oil on canvas, 81 × 100 cm
Musée National d'Art Moderne, Centre Georges Pompidou, Paris

OPPOSITE
Sylvia GOSSE
36. *Rue Cousin, Dieppe* 1938
oil on canvas, 58.5 × 48.25 cm
Michael Parkin Gallery, London

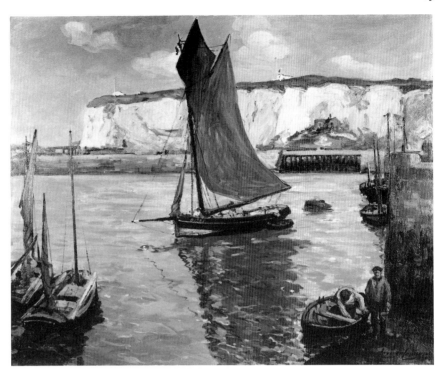

Alexander JAMIESON
41. *Dieppe Cliffs* 1904
oil on canvas, 63.5 × 76 cm
The Royal Pavilion, Art Gallery and Museums, Brighton

Born in Rouen, Hodé was self-taught: *Dieppe Harbour* is clearly the work of an autodidact. He was secretary of the Société des Peintres Normands, as well as exhibiting at the Salon d'Automne and Salon des Indépendants in Paris.

Louis-Gabriel-Eugène ISABEY (1803–86)
French
40. *Fish Market, Dieppe* 1845
oil on panel, 35.6 × 53 cm
The Trustees of the National Gallery, London (ill. p. 18)

Eugène Isabey was the son and pupil of Jean-Baptiste Isabey. His work relates particularly to Delacroix and Bonington. Isabey introduced his pupil Jongkind to the Normandy coast in 1847, and in the 1820s had himself been one of the first French painters to look for subjects there. (See also

for example Corot's *Dieppe – Panoramic view from the outskirts* 1823; sold Sotheby's New York, 24 February 1987.)

Alexander JAMIESON (1873–1937)
British
41. *Dieppe Cliffs* 1904
oil on canvas, 63.5 × 76 cm
The Royal Pavilion, Art Gallery and Museums, Brighton (ill. p. 63)

Born in Glasgow, Jamieson studied there and in Paris. He rapidly established himself in Paris as a painter of French landscapes. He often painted in Dieppe, where his subjects included the church of Saint Jacques, the market, harbour, and cliffs.

Gerald KELLY (1879–1972)
British
42. *The Promenade, Dieppe* 1906
oil on canvas, 26.6 × 20.9 cm
Michael Parkin Gallery, London (ill. p. 39)

Painter of portraits and landscapes, Kelly lived in Paris in the 1900s and exhibited successfully at the Salon d'Automne.

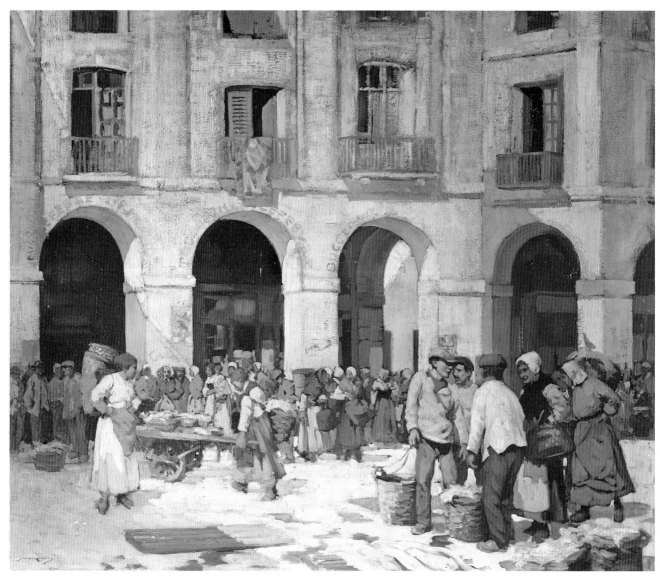

Albert LEBOURG (1849–1928)
French
43. *View of Dieppe (Vue de Dieppe)* 1896
oil on canvas, 25 × 33 cm
Musée des Beaux-Arts, Rouen

44. *Dieppe Harbour (Le Port de Dieppe)* 1896
oil on canvas, 37.5 × 47.5 cm
Château-Musée de Dieppe

The Norman landscape-painter Lebourg
returned again and again to work at
Dieppe. He showed at the fourth and fifth
Impressionist exhibitions in 1879 and 1880.

William LEE-HANKEY
45. *Fish Market, Dieppe*
oil on canvas, 104.6 × 124.4 cm
© Manchester City Art Galleries

William LEE-HANKEY (1869–1952)
British
45. *Fish Market, Dieppe*
oil on canvas, 104.6 × 124.4 cm
Manchester City Art Galleries (ill. p. 64)

Portrait and landscape painter and engraver,
Lee-Hankey studied partly in Paris. He

made paintings and etchings of French sub-
jects, including Dieppe.

Thérèse LESSORE (1884–1945)
British
46. *The Dressmaker, Dieppe* 1920
pencil and watercolour on paper,
31.75 × 22.6 cm
University of Hull Art Collection (ill. p. 66)

Lessore's first one-person exhibition was
held in London in 1918, with a catalogue
preface by Sickert. She was born in
Brighton and, after her marriage to Sickert

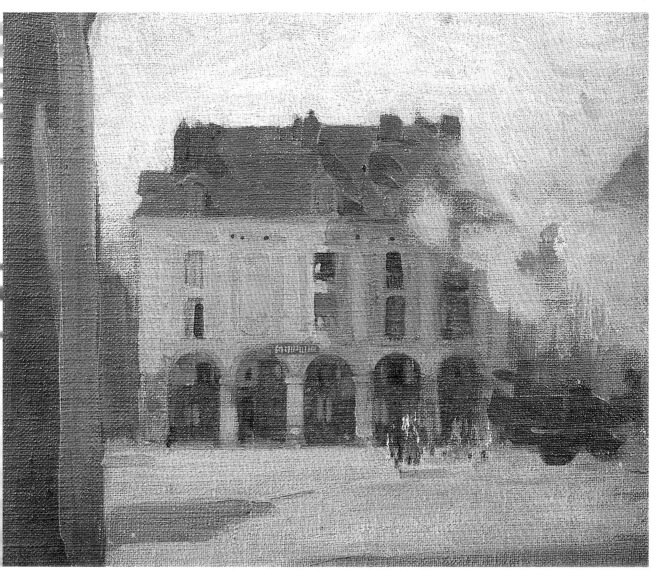

William NICHOLSON
52. *Dieppe Harbour c.* 1905
oil on canvas, 22.5 × 33 cm
Private Collection
Photo Glen Segal, Five 4 Photographics

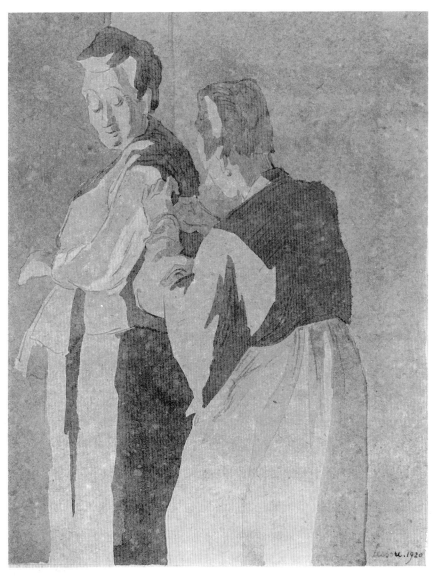

Thérèse LESSORE
46. *The Dressmaker, Dieppe* 1920
pencil and watercolour on paper,
31.75 × 22.6 cm
University of Hull Art Collection
Photo Brynmor Jones Library

in 1926, lived briefly with him there. Her
work grew close to his, and she helped him
to produce his late paintings.

 This drawing was owned by Sylvia Gosse
(q.v.) and may represent Sickert's maid
Marie Pepin with the dressmaker.

Robert LOTIRON (1886–1966)
French
47. *Dieppe Harbour (Le Port de Dieppe)* 1920
oil on canvas, 55 × 82 cm
Musée des Beaux-Arts, Nantes

Lotiron showed several recent paintings of
Dieppe in an exhibition shared with
Duncan Grant and Vanessa Bell at the
Independent Gallery in London in Novem-
ber 1920. On his visits to Dieppe (1920,
1921, 1932, 1948, 1953) his favoured sub-
ject was the life of the quay. His work
between the wars reconciles naturalism with

a knowledge of Cézanne and early
Cubism, and is allied to that of painters
such as de la Fresnaye, de Segonzac and
Luc-Albert Moreau.

Joan MIRÓ (1893–1983)
Spanish
48. *Flight of a Bird over the Plain IV (Le Vol
d'un Oiseau sur la Plaine IV)* 1939
oil on canvas, 81 × 100 cm
Eric Estorick Family Collection (ill. p. 76)

Miró was first in Varengeville in the sum-
mer of 1937, staying again the following
summer in the house of the architect Paul
Nelson, where he painted a mural. He
returned in August 1939 shortly before the
outbreak of war. On the train journey from
Paris he observed the heavy flight of crows
over the Normandy plains: the group of
paintings, of which this one is the fourth
and last, relates to this experience. There is
a preparatory drawing for the work which
also includes a large shining sun in the top
left portion of the composition (pencil on
paper, 21 × 27 cm; Fundació Joan Miró,
Barcelona).

 Between August and December Miró
painted two series of small paintings, one on
red grounds and one on burlap. Then
between January and his enforced departure
in May due to the German offensive, he
made the first ten gouaches in the celebrated
series of *Constellations*, characterized by a
proliferation of signs, stars, birds and per-
sonages, and often bearing extravagant
poetic titles. Miró recalled: 'At
Varengeville-sur-Mer, in 1939, began a new
stage in my work which had its source in
music and nature. It was about the time that
the war broke out. I felt a deep desire to
escape. I closed myself within myself
purposely. The night, music, and the stars
began to play a major role in suggesting my
paintings. . . Also the material of my paint-
ing began to take a new importance.'
(*Partisan Review* (New York) February
1948.)

Claude MONET (1840–1926)
French
49. *Varengeville Church (L'Eglise de
Varengeville à Contre-Jour)* 1882
oil on canvas, 65 × 81 cm

The Barber Institute of Fine Arts, The University of Birmingham (ill. p. 20)

Monet grew up in Le Havre where he was introduced to landscape painting by Boudin around 1856.

Renoir encouraged him to visit Dieppe in 1882, and Renoir's recent paintings of the cliffs probably affected Monet's own (see for example Renoir's *The Cliffs of Pourville* 1879 and *Varengeville Church and the Cliffs c. 1879*). Monet made two long visits in 1882, from February to April and from June to October, staying at Pourville on the coast to the west of Dieppe. From this very productive period date about a hundred

Ben NICHOLSON
50. *Bocque* 1932
oil and pencil on board, 48 × 78.5 cm
Arts Council Collection, The South Bank Centre, London
Reproduced by permission of Angela Verren-Taunt

paintings. The summer sunset of *Varengeville Church* (cat. 49) is painted in a rich contrast of heightened oranges and greens. This striking composition owes much to Japanese prints. Monet made two other paintings from the same viewpoint, one in dull weather and another at sunset.

Monet returned in 1896 and 1897, taking up favourite motifs such as the coastguard's cottage on the cliffs at Varengeville, now conceived in sustained series, painted at different times of day and in contrasting weather conditions.

Ben NICHOLSON (1894–1982)
British
50. *Bocque* 1932
oil and pencil on board, 48 × 78.5 cm
Arts Council Collection, The South Bank Centre, London (ill. p. 67)

51. *Auberge de la Sole Dieppoise* 1932
oil, gesso and pencil on board, 93.7 × 75.9 cm
The Trustees of the Tate Gallery (ill. p. 45)

As a child Nicholson spent summer holidays with his father William (q.v.) and family in Dieppe. He visited again in 1932 with the sculptor Barbara Hepworth, and the group of paintings which he made on his return to London included cardinal works such as *Auberge de la Sole Dieppoise* (cat. 51) and *Au Chat Botté* (Manchester City Art Galleries) which were an entirely personal interpretation of the Cubism of Braque and Picasso. *Bocque* (cat. 50) comes from Bocquet, the brand-name of a well-known mustard made in Yvetot, a small town between Dieppe and Le Havre.

In January 1933, Nicholson visited Braque (q.v.) in Paris. Nicholson and Hepworth probably went to see Braque at his house in Varengeville, on the coast west of Dieppe, twice in 1933 (April and September).

In the 1930s Nicholson assumed a leading role in the English avant-garde. He was frequently in Paris in the first half of the decade

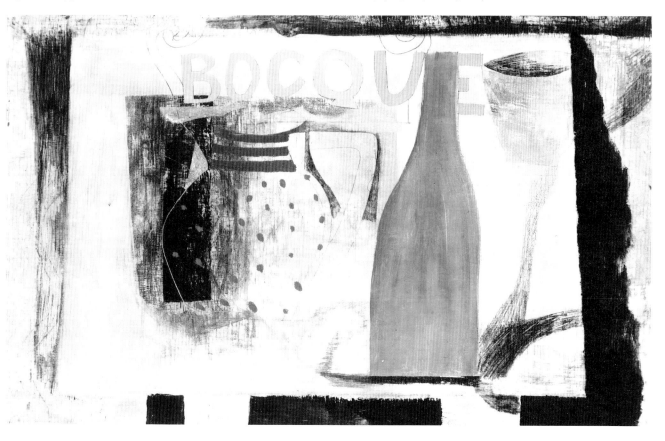

Charles CONDER
15. *Dieppe* (detail) 1895
oil on canvas, 33.2 × 46.5 cm
Manchester City Art Galleries

John Duncan FERGUSSON
21. *Dieppe, 14 July 1905: Night* 1905
oil on canvas, 76.8 × 76.8 cm
Scottish National Gallery of Modern Art, Edinburgh

and played a part in the artistic life of Paris, establishing friendships with artists such as Braque, Miró, Calder and Mondrian and joining the Paris-based group Abstraction-Création in 1933. He made his first abstract relief in December 1933 and the white reliefs which soon followed secured his international reputation.

Nicholson and Hepworth were again in Varengeville in the summer of 1937, at the invitation of Alexander Calder. Here they also saw Miró.

William NICHOLSON (1872–1949)
British
52. *Dieppe Harbour* c. 1905
oil on canvas, 33 × 25.5 cm
Private Collection (ill. p. 65)

52. *Hoisting the Flag, Customs House, Dieppe*
c. 1910
oil on canvas, 33 × 28 cm
Private Collection (ill. p. 29)

Father of Ben (q.v.), William was a painter of still lifes, landscapes and portraits, and an innovative maker of posters and woodcuts. He studied partly in Paris at the Académie Julian. Seven paintings of Dieppe by him are known. He spent summer holidays in Dieppe in 1903, 1905 and 1907 with his family and friends, such as Max Beerbohm, Beerbohm's half-brother the actor-manager Herbert Beerbohm Tree, Reggie Turner, the actress Constance Collier, the actress Marie Tempest and her husband Cosmo Gordon-Lennox. He saw Sickert and Blanche while he was there.

Nicholson painted a group of Dieppe street fronts, for example *The Blue Shop* (c. 1900; Art Gallery of New South Wales, Sydney). Like Sickert's paintings of the same subjects, these are influenced by Whistlers, such as *A Shop with a Balcony* (cat. 88; c. 1897). *La Place du Petit Enfer* of 1908 (A.W. Bacon, on loan to the Castle Museum, Nottingham) also owes something to James Pryde, his brother-in-law, especially in the depiction of the high street façades like stage flats.

The small *Dieppe Harbour* (cat. 52) of about 1905 shows a train emerging from the Gare Maritime with the Arcades de la Poissonnerie beyond. The Arcades are also

visible in *Hoisting the Flag* (cat. 53; c. 1910), which was painted when Nicholson was living at Rottingdean, on the Sussex coast between Brighton and Newhaven, within easy reach of Dieppe.

Camille PISSARRO (1830–1903)
French
54. *The Church of Saint Jacques in Dieppe* (*L'Eglise Saint Jacques à Dieppe*) 1901
oil on canvas, 54.5 × 65.5 cm
Paris, Musée d'Orsay (ill. p. 13)

55. *The Fair at Dieppe, sunshine, afternoon* (*La Foire à Dieppe, soleil, après-midi*) 1901
oil on canvas, 73 × 91.8 cm
Philadelphia Museum of Art (Bequest of Lisa Norris Elkins) (ill. p. 73)

At the end of his life, in search of new subjects to paint, Pissarro visited Dieppe and the surrounding region in four successive years. In 1899 and 1900 he was at Arques, Varengeville, Dieppe and Berneval. He made seven rural paintings in Varengeville and another seven in Berneval (numbers 1083–9 and 1143–9 respectively in L-R. Pissarro and L. Venturi, *Camille Pissarro, son art – son oeuvre* (Paris, 1939)). Then, in July 1901, Pissarro began his first painting 'campaign' in Dieppe. From his room in the Hôtel du Commerce overlooking the Place Nationale, he painted the church of Saint Jacques, the fair and the market in differing weather and light conditions and taking varying viewpoints. *The Fair at Dieppe* and *The Church of Saint Jacques* belong to this group of nine paintings. *The Church* is painted from a viewpoint further to the left: partly hidden by the carrousel on the left of *The Fair* is the corner of the church. Boudin's pair of paintings of the Place Nationale on market day dating from only a few years earlier make an interesting comparison with Pissarro's paintings of the same motif (see especially Boudin's *Dieppe: Place Nationale un Jour de Marché* 1896; sold Sotheby's London, 2 July 1980).

Sickert invited Pissarro to dinner early in September: fellow-guest Max Beerbohm described him in a letter as 'a great dear, very amusing and sweet and patriarchal' (*Letters to Reggie Turner* (London, 1964) p. 146).

The following year Pissarro stayed in Dieppe again, renting a workroom in the Arcades de la Poissonnerie. He concentrated on painting the activity of the harbour: 'My motifs are very beautiful, the fish-market, the outer harbour, the port Duquesne, le Pollet, in rain, sun, smoke etc., etc.' he wrote to his son Lucien (*Lettres à son fils Lucien* (Paris, 1950) p. 492). He made about twenty paintings in 1902, including one which he gave to the Dieppe museum and another in the Musée d'Orsay, *Dieppe, bassin Duquesne (marée basse, soleil, matin)*. There is a sketchbook in the Ashmolean Museum, Oxford, dating in part from his Dieppe visits, but not related to any specific painting.

William RATCLIFFE (1870–1955)
British
56. *Dieppe* c. 1913–14
oil on canvas, 50.8 × 61 cm
City of Aberdeen Art Gallery and Museums Collection (ill. p. 71)

57. *Rooftops, Dieppe* c. 1913–14
watercolour on paper, 37 × 49.5 cm
Michael Parkin Gallery, London

Harold Gilman encouraged Ratcliffe to return to painting after working for many years as a wallpaper designer, and introduced him to the Fitzroy Street circle. Ratcliffe was a founder-member of the Camden Town Group. Sickert may have suggested that Ratcliffe paint in Dieppe in 1913 or 1914.

Auguste RENOIR (1841–1919)
French
58. *Self-portrait* (*Portrait de l'artiste*) 1879
oil on canvas, 18 × 14 cm
Paris, Musée d'Orsay (ill. p. 24)

Renoir first visited the house of his friend and patron Paul Bérard, the Château de Wargemont, east of Dieppe, in the summer of 1879. He frequently returned, painting portraits of the Bérard family, and pictures of the house and its gardens, and of the surrounding landscape and coast. Notable among these are *Mussel-fishers at Berneval* 1879 (Barnes Foundation, Philadelphia), *Landscape at Wargemont* 1879 (Toledo Museum of Art), *Children's afternoon at Wargemont* 1884 (Nationalgalerie, Berlin).

William RATCLIFFE
56. *Dieppe c.* 1913–14
oil on canvas, 50.8 × 61 cm
City of Aberdeen Art Gallery and Museums
Collection

Fourteen years later he painted *Breakfast at
Berneval* 1898 (private collection). He also
painted decorative works in the Château,
and for J.-E. Blanche's studio at Bas-Fort
Blanc (*Apparition de Vénus à Tannhäuser* and

Wolfram et Vénus). In all, Renoir was in the
region in 1879, 1880, 1881, 1882, 1884,
1885, 1895 and 1898. He gave the small
self-portrait shown here to Bérard's valet.
(See also Monet.)

William ROTHENSTEIN (1872–1945)
British
59. *Charles Conder* 1896
oil on canvas, 121.5 × 56 cm
Paris, Musée d'Orsay (ill. p. 36)

60. *Portrait of Charles Conder* 1896
pencil on paper, 26.4 × 36.2 cm
National Portrait Gallery, London

A fellow student with Charles Conder
(q.v.) in Paris, Rothenstein shared an
exhibition there with him in 1891 and they
remained close friends. He knew Whistler
and his admiration is reflected in the portrait
of Conder which is exhibited here (cat. 59).
Rothenstein joined Conder in Dieppe for

Harold GILMAN
26. *The Swing Bridge, Dieppe (Le Pont Tournant, Dieppe)* 1911
oil on canvas, 30.5 × 40.6 cm
Private Collection
Photo Roy Farthing

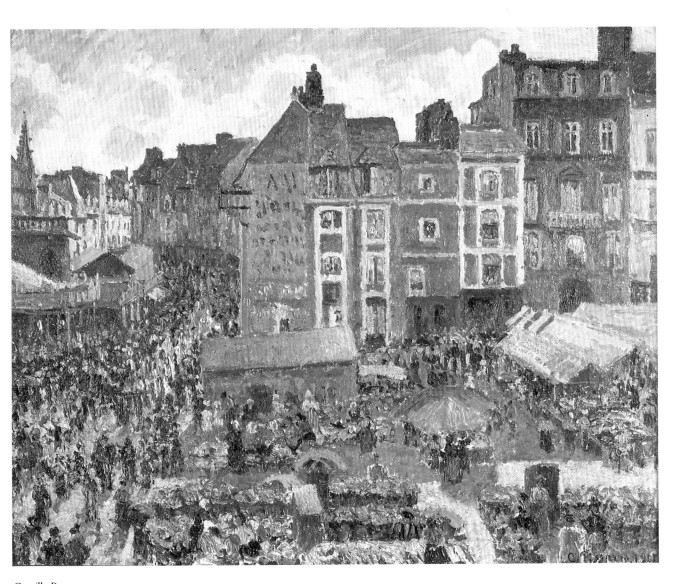

Camille PISSARRO
55. *The Fair at Dieppe, sunshine, afternoon*
(*La Foire à Dieppe, soleil, après-midi*) 1901
oil on canvas, 73 × 91.8 cm
Philadelphia Museum of Art (Bequest of Lisa Norris Elkins)

a short visit in the late summer of 1895 and met J.E. Blanche, whom he came to know well. He went over again in 1897 to visit Oscar Wilde. In 1899 he began his honeymoon in Dieppe and was met off the boat by Sickert.

Henri ROUSSEAU, the Douanier
(1844–1910)
French
61. *The Cliff (La Falaise)*
oil on canvas, 22 × 35 cm
Musée de l'Orangerie, Collection Jean Walter & Paul Guillaume

The self-taught painter Rousseau began to paint in about 1880, exhibiting at the Indépendants from 1886 and winning wide admiration from the Parisian avant-garde. *La Falaise* is one of Rousseau's rare seascapes. It is not known whether he visited the region of Dieppe. It has even been suggested that the painting is his version of Monet's Dieppe cliff scenes, either seen in an exhibition in Paris or in reproduction.

Henry RUSHBURY (1889–1968)
British
62. *The Swing Bridge, Dieppe* 1920

Bernhard SICKERT
65. *Dieppe* 1897
oil on panel, 47 × 56 cm
Peter and Katharine Makower. Photo John Cass

pencil and watercolour wash on paper, 23.5 × 31 cm
Birmingham Museums and Art Gallery

63. *Château de Dieppe* 1920
pencil and chalk on paper, 26.6 × 34.4 cm
Birmingham Museums and Art Gallery

Watercolour painter, draughtsman and etcher, Rushbury visited Dieppe in 1920 on a sketching tour.

Otto SCHOLDERER (1834–1902)
German
64. *Marine*
oil on canvas, 24.5 × 51.8 cm
Paris, Musée d'Orsay (ill. p. 22)

The German painter Scholderer spent

periods of his life in both London and
Paris. In Paris in 1858–9 and 1868–70 he
frequented Courbet's studio and the circles
of Manet and particularly Fantin-Latour:
he was included in Fantin-Latour's famous
homage to Manet, *Un Atelier aux Batignolles*
(1870). He lived for most of the last thirty
years of his life in London where, as a result
of his friendship with Sickert's father, he
gave the young Sickert painting lessons.

Bernhard SICKERT (1863–1932)
British
65. *Dieppe* 1897
oil on panel, 47 × 56 cm
Peter and Katharine Makower (ill. p. 74)

Bernhard Sickert showed alongside his
older brother Walter in the exhibition
'London Impressionists', organized by
Walter in London in 1889, and he shared
a major exhibition with Walter in 1895 at
the Dutch Gallery in London. He was a
member of the New English Art Club. He
generally painted landscapes on a small
scale. *Dieppe* dates from one of his frequent
stays in Dieppe with his brother and shows
the influence of Whistler's small oil panels.
Bernhard knew Whistler well and wrote a
book about him in 1908.

 The panel was a wedding present from the
artist to Stanley Victor Makower (1872–
1911), writer, music critic and member of
the *Yellow Book* circle.

Walter Richard SICKERT (1860–1942)
British
66. *Café des Tribunaux c.* 1890
oil on canvas, 60.3 × 73 cm
The Trustees of the Tate Gallery (ill. p. 35)

67. *L'Hôtel Royal, Dieppe c.* 1894
oil on canvas, 50.5 × 61 cm
Sheffield City Art Galleries (ill. p. 26)

68. *L'Hôtel Royal, Dieppe c.* 1899
oil on canvas, 46.3 × 61 cm
Ferens Art Gallery, Hull City
Museums & Art Galleries (ill. p. 40)

69. *Dieppe, la rue Notre-Dame c.* 1899–1900
Watercolour, ink and pencil, 26.5 × 22.5 cm
Musée des Beaux-Arts, Rouen (ill. p. 42)

70. *Dieppe, la rue Notre-Dame c.* 1899–1900
oil on canvas, 55 × 46 cm
Château-Musée de Dieppe

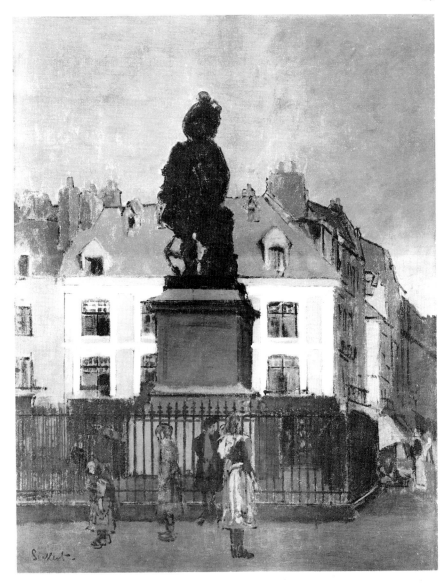

71. *Les Arcades de la Poissonnerie, Dieppe
c.* 1900
oil on canvas, 61 × 50.2cm
The Trustees of the Tate Gallery (ill. p. 42)

72. *Saint Jacques Façade c.* 1899–1900
oil on canvas, 55.9 × 48.2 cm
Whitworth Art Gallery, University of
Manchester (ill. p. 14)

73. *Saint Rémy c.* 1900
oil on canvas, 14 × 24 cm
Private Collection (ill. p. 25)

Walter Richard SICKERT
74. *Le Grand Duquesne, Dieppe* 1902
oil on canvas, 130 × 100.3 cm
Manchester City Art Galleries

74. *Le Grand Duquesne, Dieppe* 1902
oil on canvas, 130 × 100.3 cm
Manchester City Art Galleries (ill. p. 75)

75. *The Bathers, Dieppe c.* 1902
oil on canvas, 131.5 × 104.6 cm
Trustees of the National Museums and Gal-
leries on Merseyside (Walker Art Gallery)
(ill. p. 80)

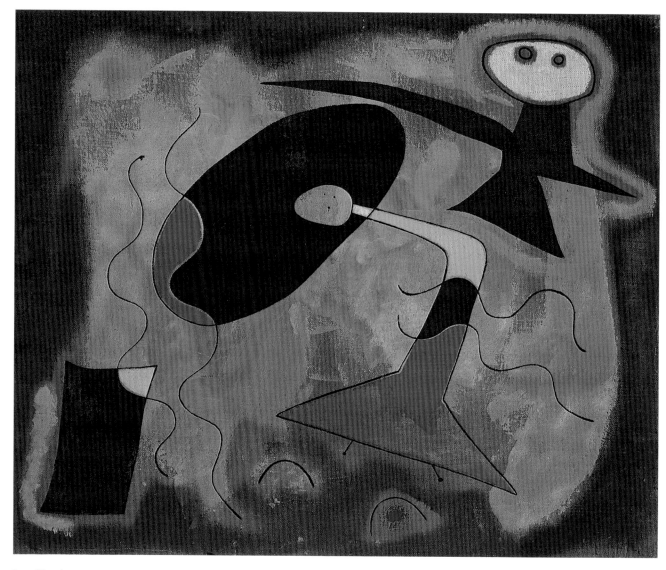

Joan MIRÓ
48. *Flight of a Bird over the Plain IV (Le
Vol d'un Oiseau sur la Plaine IV)* 1939
oil on canvas, 81 × 100 cm
Eric Estorick Family Collection
Herbert Michael Fotograf
© ADAGP, Paris and DACS, London 1992

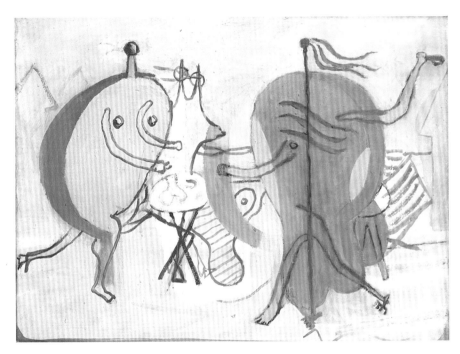

Georges BRAQUE
13. *The Beach (La Plage)* 1932
oil on canvas, 30.5 × 41 cm
Collection M. et Mme Claude Laurens
Photo property of the Laurens archives
© ADAGP, Paris and DACS, London 1992

Matthew SMITH
81. *French Port* [Dieppe] (detail) *c.* 1926
oil on canvas, 60.5 × 73 cm
Guildhall Art Gallery, Corporation of London
(Mary Keene Bequest)
Reproduced by permission
of the Guildhall Library, London
Godfrey New Photographics

76. *The Inner Harbour (La Darse) c.* 1902
oil on canvas, 151.2 × 53.4 cm
Private Collection (ill. p. 15)

77. *The Inner Harbour (La Darse) c.* 1902
oil on canvas, 151.2 × 53.4 cm
Glasgow Art Gallery and Museum

78. *La rue Mortier d'Or* 1903
oil on canvas, 14 × 24 cm
Private Collection, USA, Courtesy The
Fine Art Society, London

79. *Portrait of J-E. Blanche c.* 1910
oil on canvas, 61 × 50.8 cm
The Trustees of the Tate Gallery

80. *Dieppe Races c.* 1920–26
oil on canvas, 50.6 × 61.1 cm
Birmingham Museums and Art Gallery

Sickert's long association with Dieppe
began with holidays spent there as a child.
After studying at the Slade, Sickert became

Whistler's pupil and assistant in London in
1882. He accompanied Whistler's *Portrait of
the Painter's Mother* to the Paris Salon in
1883, crossing by Dieppe, carrying a letter
of introduction to Degas. He recalled:
'I have a clear recollection of the vision of
the little deal case swinging from a crane
against the star-lit night and the sleeping
houses of the Pollet de Dieppe.' ('Degas',
Burlington Magazine, November 1917.)
 Sickert spent the summer of 1885 in
Dieppe, and Whistler came to stay with
him in September. Whistler's influence is
strong in the paintings Sickert made there,

such as the small seascape on panel *La Plage, Dieppe* (Manchester City Art Galleries) which is very much like those by Whistler himself. Sickert would always admire Whistler's little panel-paintings and a Whistlerian streak remained in his work. However, it was the contact with Degas in Dieppe that brilliant summer which turned Sickert decisively away from Whistler's example. Degas was staying with the Halévys (neighbours of Blanche). His pastel *Six Friends at Dieppe* (Museum of Art, Rhode Island School of Design, Providence, USA; 1885) includes both Sickert and Blanche. The friendship between Sickert and Blanche (q.v.), centred on Dieppe where Sickert spent most summers, dates from this year. Among the many paintings which Blanche bought from Sickert is *L'Hôtel Royal* (cat. 67; c. 1894), a subject he often painted (compare the later version, cat. 68).

In 1898 Sickert left London for Dieppe, which was his base for the next seven years. In these years he produced a remarkable record of the town he loved. He wrote to a friend in 1899, 'this place Dieppe, is my only up to now, goldmine.' Among his favourite subjects were the church of Saint Jacques, the statue of Admiral Duquesne in the Place Nationale, the Arcades on the quayside and the rue Notre-Dame which runs between there and Saint Jacques (cats 69, 70, 71, 72, 74).

It was Sickert's practice to paint in the studio from preparatory drawings, but in 1899–1900 he made a group of highly finished coloured drawings of preferred motifs to sell, such as *La rue Notre-Dame* (cat. 69). He may well have used the same working drawings to make this watercolour and the closely related painting of the same view at the same time (cat. 70).

In 1902 Sickert was commissioned by a Dieppe hotel proprietor to paint four large works to hang in a café (they were in fact immediately sold by the dissatisifed hotel-keeper). Of the four similarly sized bold canvases, *La rue Notre-Dame and the Quai Duquesne* (National Gallery of Canada, Ottawa), *Saint Jacques* (private collection), *Le Grand Duquesne* and *The Bathers*, the lat-

ter two are shown here (cats 74, 75). The four works are the culmination of Sickert's work in Dieppe since 1898, with the exception of *The Bathers*, which is a unique composition, probably painted using a snapshot. The pair of very tall paintings of *La Darse*, of the same year, may also relate to the commission (cats 76, 77: cat. 76 is the untraced painting referred to by Wendy Baron in *Sickert* (London, 1973) pp. 69 and 329).

After his return to London, encouraged by Spencer Gore (q.v.), Sickert continued to spend his summers in Dieppe, for example joining Gore there in 1906.

Between 1919 and 1922 Sickert lived first at Envermeu, a village inland from Dieppe, and then in the town itself. He painted still lifes, portraits, café and casino pictures, bedroom subjects and landscapes. One of these last works made by Sickert in Dieppe is *Dieppe Races* (cat. 80), a remarkable picture inspired by Degas and painted from photographs.

Matthew SMITH (1879–1959)
British
81. *French Port* [Dieppe] *c.* 1926
oil on canvas, 60.5 × 73 cm
Guildhall Art Gallery, Corporation of London (Mary Keene Bequest) (ill. p. 78)

Smith lived intermittently in France between 1908 and 1940 and was in Dieppe in 1909, 1926, 1929 and 1957. There are several paintings of Dieppe harbour dating from his long stay in 1926, as well as rapid pen-and-pencil sketches of the harbour and streets (Guildhall Art Gallery).

During Smith's visit in 1929 Christopher Wood was staying in the same hotel (q.v.).

Arthur STUDD (1863–1919)
British
82. *The Beach and Boulevard de Verdun, Dieppe*
c. 1899
oil on panel, 15.25 × 21.5 cm
Michael Parkin Gallery, London
(ill. p. 79)

Studd was at the Slade and the Académie Julian, Paris, with William Rothenstein (q.v.). Together they met Whistler in Paris in 1892. Studd worked with Whistler in

Arthur STUDD
83. *The Beach and Boulevard de Verdun, Dieppe*
c. 1899
oil on panel, 15.25 × 21.5 cm
Michael Parkin Gallery, London

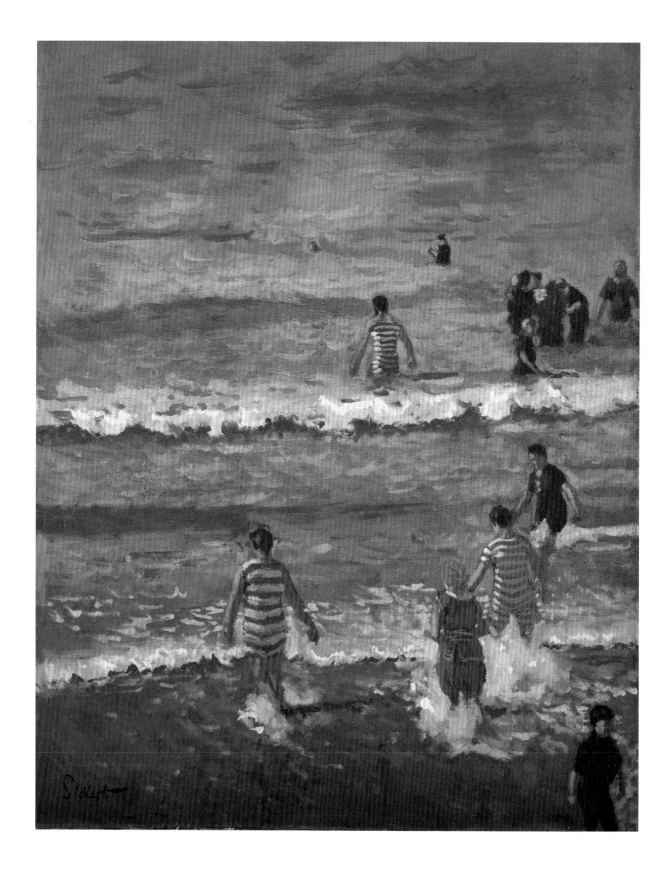

1894 and 1895, and they were neighbours in Chelsea for some years. These panels are indebted to Whistler's beach and seascapes.

Studd was also a collector and he bequeathed three major Whistlers to the National Gallery (now in the Tate Gallery) – *The Little White Girl*, *The Fire Wheel* and *Cremorne Lights*.

J.M.W. TURNER (1775–1851)
British
83. *Château d'Arques, nr Dieppe c.* 1834
watercolour on paper, 15.3 × 22.7 cm
The Royal Pavilion, Art Gallery and Museums, Brighton (ill. p. 81)

84. *Château d'Arques, nr Dieppe* 1834
watercolour on paper, 9.5 × 14.6 cm
By permission of the Provost and Fellows of Eton College (ill. p. 17)

Turner travelled through Dieppe on several occasions, for example in 1821 and 1845. There are a considerable number of studies of the town and its inhabitants in his sketchbooks. He used drawings from one sketchbook as the basis for the two tiny watercolours of the Château d'Arques shown here (sketchbook CCXVI, Turner Bequest, British Museum). Both were made some years after the sketches, in about 1834, when Turner was illustrating Sir Walter Scott's *Tales of a Grandfather* for an edition of his prose works. The intricate Eton watercolour was subsequently engraved for the volume by W. Forrest.

A grandiose painting of the *Harbour of Dieppe*, based on sketches made on the 1821 visit, is in the Frick Collection, New York (exhibited at the Royal Academy in 1825).

Félix VALLOTTON (1865–1925)
Swiss (naturalized French)
85. *Fishermen watching the return of the catch* (*Marins regardant le retour de la pêche*) 1903
oil on canvas, 53 × 77 cm
Private Collection, Paris (ill. p. 81)

86. *Landscape with Red Roof, Varengeville* (*Paysage au toit rouge, Varengeville*) 1904
oil on canvas, 33 × 60 cm
Private Collection, Switzerland

87. *The Bather* (*Le Bain*) 1905
Oil on board, 88 × 66 cm
Private Collection (ill. p. 32)

The Franco-Swiss artist Félix Vallotton worked much in Normandy. He painted at Dieppe in 1899 when he rented the

J.M.W. TURNER
83. *Château d'Arques, nr Dieppe c.* 1834
watercolour on paper, 15.3 × 22.7 cm
The Royal Pavilion Art Gallery and Museums, Brighton

Félix VALLOTTON
85. *Fishermen watching the return of the catch* (*Marins regardant le retour de la pêche*) 1903
oil on canvas, 53 × 77 cm
Private Collection, France

Château d'Etretat. In 1903 he stayed at Arques and painted landscapes there and in Dieppe itself, such as *Fishermen watching the return of the catch* (cat. 85). From July to September of 1904 Vallotton was at Varengeville working on a notable group of interiors and landscapes, including *Landscape with Red Roof* (cat. 86). *The Bather* (cat. 87), painted the following year, shows a nude bather beside local cliffs.

In July, Bonnard came to see him at Varengeville: announcing his arrival, Bonnard wrote to Vallotton that he was coming for a rest but would pack some paints in case 'the contagion infects me' (letter of 22 July, quoted in Vallotton, *Documents pour une Biographie et pour l'Histoire d'une Oeuvre*, vol. 2, 1900–1914 (Lausanne and Paris, 1974), p. 80).

James McNeill WHISTLER (1834–1903)
American (British school)
88. *A Shop with a Balcony c.* 1897
oil on panel, 22.3 × 13.7 cm
Hunterian Art Gallery, University of Glasgow (Birnie Philip Bequest) (ill. p. 24)

The American-born Whistler studied in Paris in the mid 1850s, joining the circle of Courbet. He moved to London in 1859 and spent much of the rest of his life there. He was a vital link between the French and English avant-gardes, moving frequently between Paris and London: Max Beerbohm captured this in his caricature of Whistler travelling by broomstick between the two capitals, *A Nocturne: Mr Whistler Crossing the Channel*, published in the *Idler*, February 1899. Whistler was a regular visitor to Dieppe. Around twenty works whose location is identified were painted there and on the coast nearby. In the summer of 1885 he stayed with Sickert (q.v.) in Dieppe. He repeated the 'Ten O'Clock' lecture, explaining his aesthetic creed, which he had first given in London in February. He did a portrait of Olga Caracciolo which Blanche bought from him. As was his practice, he made small oil panels, rapidly and sparely painted in muted, modulated colours, of street fronts, seascapes and beach scenes, such as *Green and Violet: The Evening Walk, Dieppe* (private collection,

Jersey). These were of great importance to Sickert and many others (see Fergusson, Helleu, Kelly, William Nicholson, Rothenstein, Bernhard Sickert, Studd). A late example from the 1890s, *A Shop with a Balcony*, is exhibited here (cat. 88).

Whistler was probably again in Dieppe in 1888 during his honeymoon. In September 1896 he spent two weeks painting around Dieppe and Calais. And he was back in Dieppe in July 1897, with Joseph and Elizabeth Pennell and Edward G. Kennedy. 'He had hardly arrived at Dieppe before the small paint-box was unpacked, and he was in the street hunting for a little shop-front he remembered.' (J. and E.R. Pennell, *The Life of James McNeill Whistler* (London, 1908) vol. 2 p. 195; compare *A Shop with a Balcony*.)

In August 1898 Whistler was briefly in Dieppe on the way to London. Between July and October of the following year, he was based at Pourville near Dieppe, con-

Terrick WILLIAMS
90. *The Harbour, Dieppe* 1931
oil on canvas, 76.2 × 94.3 cm
Manchester City Art Galleries

valescing with the Birnie Philips. His small panels, such as *Green and Silver: The Great Sea* (Hunterian Art Gallery, University of Glasgow), were now wilder and more vigorously brushed.

Whistler visited Dieppe for the last time in July 1901.

Oscar WILDE (1856–1900)
British
89. Manuscript of *De Profundis*
The British Library Board

When he arrived in Dieppe in May 1897 on his release from Reading gaol, Wilde was already a familiar visitor – he had spent part of his honeymoon there in 1884, for example. Now he was carrying with him in a large sealed envelope the manuscript of *De Profundis* which he had composed during his imprisonment in the form of a letter to Lord Alfred Douglas, and he handed it over to Robert Ross who met him off the boat. Ross presented the manuscript to the British Museum in 1909 with the proviso that it should be kept sealed for fifty years. Douglas brought a libel action over the work, which was finally published in a complete edition in 1962.

Wilde settled at Berneval, on the coast east of Dieppe, where he composed much of *The Ballad of Reading Gaol* (it was finished in Naples later in the year). His visitors at Berneval included Lugné-Poe, André Gide and William Rothenstein. Of his painter friends then in Dieppe – Sickert, Conder, Beardsley and Blanche – only Conder treated him warmly.

Terrick WILLIAMS (1860–1936)
British
90. *The Harbour, Dieppe* 1931
oil on canvas, 76.2 × 94.3 cm
Manchester City Art Galleries (ill. p. 82)

Painter of landscapes and marines. Born in Liverpool, he studied in Antwerp and Paris and exhibited at the Royal Academy.

Christopher WOOD (1901–30)
British
91. *The Quay, Dieppe* 1929
oil on board, 41.5 × 56.2 cm
City of Aberdeen Art Gallery and Museums Collections (ill. p. 83)

92. *Fishing Boat, Dieppe* 1929
pencil on paper, 32 × 40.7 cm
City of Aberdeen Art Gallery and Museums Collections

Wood was in Dieppe in April and May 1929. He made about six paintings and a group of drawings, concentrating on the harbour and boats. 'Dieppe was a complete happiness. I have never known it before', he wrote to Winifred and Ben Nicholson. 'Kit is working passionately', wrote his companion Frosca Munster. 'He doesn't put

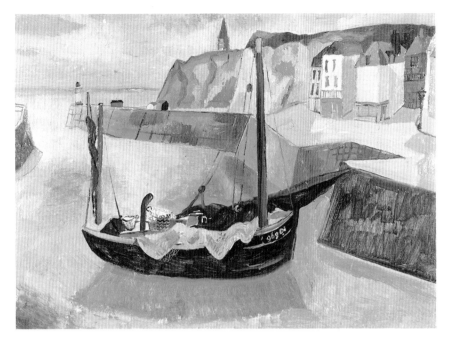

Christopher WOOD
91. *The Quay, Dieppe* 1929
oil on board, 41.5 × 56.2 cm
City of Aberdeen Art Gallery and Museums Collections

down his paintbrush for a moment, walks the length of the quays and adores the boats as always.' (Both letters to the Nicholsons are in Tate Gallery Archive; quoted in *Unknown Colour. Paintings, Letters, Writings by Winifred Nicholson* (London, 1987) p. 96. Frosca translated from French.)

In the Aberdeen picture (cat. 91) Wood is looking across to Le Pollet, to the church of Notre-Dame de Bon Secours on the clifftop and out to sea. He faces the other way in *Boat in Harbour* (private collection), painting the arcades of the Quai Duquesne in the foreground and the statue of Admiral Duquesne in the Place Nationale beyond. Sickert painted the view from the Quai up a parallel street, the rue Notre-Dame, many times.

Matthew Smith was staying in the same hotel, the Hôtel Aguado on the front, and the two men met and talked. When Frosca left, Wood was joined by the dealer Pierre Colle and the painter Christian Bérard.

Chronology – Napoleon to World War II

1814 *May* Abdication of Napoleon, return of Louis XVIII.
May 25 Haydon and Wilkie sail from Brighton to Dieppe to paint in Normandy.

1815 *Jun 18* Battle of Waterloo.

1817 Cotman arrives in Dieppe after 42-hour crossing. The harpist, Naderman, composes 3 Dieppe songs.

1818 The writer Thomas Dibdin and his illustrator George Lewis visit Dieppe. Cotman tours Normandy with Dawson Turner's family.

1820 Eugène Isabey, aged 17, visits Dieppe with his father. Cotman's 3rd and last tour. J.M.W. Turner discovers Dieppe.
Aug 19 Chateaubriand is in Dieppe.

1822 The first sea-bathing establishment, later Bains Caroline, opened on west end of seafront. Construction of Bains Chauds begun. Exhibition of Cotman's watercolour of the harbour.

1823 Bonington and Corot are in the region.

1824 *May 15* *Rapid* makes first steam crossing from Brighton's new Chain Pier (washed away in 1896).
Jul 30 Caroline, Duchesse de Berry (widowed daughter-in-law of Charles X) first visits Dieppe.
Sep 1 Hazlitt crosses from Brighton to write travel articles for the *Morning Chronicle*.
Sep 16 Louis XVIII dies, succeeded by Charles X.

1825 First sea connection Newhaven-Dieppe, with wooden paddle steamers *Eclipse* and *Talbot*.
Turner's canvas of Dieppe harbour shown at the Royal Academy.

1826 David Roberts visits Dieppe. Isabey paints *L'Ouragan devant Dieppe*.
Aug Duchess lays foundation stone of theatre and presents 76 vols of Walter Scott to public library. Actors of Théâtre de Vaudeville perform *Une visite aux ruines du Château d'Arques* for her, with participation of Naderman.

1827 *Jul 16* Rossini provides music for christening of the son of the Marquis d'Aguado, his patron, who is also benefactor of Dieppe.
Aug 16 *Barbier de Seville* performed in the Dieppe theatre.

1828 Peter de Wint visits Dieppe.

1829 Opening of new half-tide dock by Duchess and completion of Bassin Bérigny.

1830 First Hôtel Royal built on the front.
July Revolution, abdication of Charles X and replacement by Louis Philippe.
Chateaubriand comes to Dieppe to see Madame Récamier.

1832 *Jun* Liszt, aged 21, takes part in a charity concert in Dieppe.

1835 *Jul 7* Chateaubriand at Hôtel

Sep 6 Fête 'Souvenir de la Bataille d'Arques' for unveiling of obelisk by Duchess.

de l'Europe in Dieppe till the 25th.
Aug 19 Victor Hugo at Dieppe (and in 1837).

1838 *Aug* Delacroix spends 2 days in Dieppe.

1841 Influx of Irish navvies and foreign workers as work starts on Paris-Rouen line.

1842 In Dieppe Isabey paints the harbour.

1843 Queen Victoria visits Louis Philippe at Eu.
May 3 Rouen-Paris railway opened. British contractors. Engineer Joseph Locke.

1844 Statue erected in main square to protestant admiral,

Abraham Duquesne. Louis Philippe visits Windsor.

1845 Queen Victoria's landing at Le Tréport for a second visit to Louis Philippe is painted by Isabey. Turner is sketching along the Norman coast.

1847 Completion of railway link from Lewes allows Newhaven to be used instead of Shoreham.
July 14 Chateaubriand in Dieppe, Arques and Longueville.

1848 *Feb 24* Louis Philippe abdicates and emigrates to England. The Republic is proclaimed in Dieppe the next day. Place Royale is now Place Nationale.

Jul 29 Official opening of the Dieppe-Rouen line.
Aug 7 Ruskin and his wife pass through Dieppe on tour of Normandy.
Dec 10 Louis Napoleon is elected president of the Second Republic.

1849 Eugène Boudin visits Dieppe.

1850 *Aug 5* Guy de Maupassant born at Miromesnil.

1851 *end Aug* Delacroix visits Dieppe for some 12 days.

1852 Courbet visits Dieppe.
Sep 6 Delacroix at Hôtel de Londres, Dieppe for a week.
Dec 2 Louis Napoleon proclaims himself Emperor.

1853 Imperial pair visit Dieppe. The Empress sketches layout of new gardens on the sea front. Re-establishment of the tobacco factory as a gesture to the town.

1854 *Aug 17* Delacroix in Dieppe till Sep 26 (and in October 1855 for 10 days).

1857 Inauguration of the new Dieppe Casino, in Paxton's style.

1860 *May 31* Birth in Munich of Walter Richard Sickert.
Jul 18 Delacroix on last visit to Dieppe. Stays for 9 days.

1862 A.F. Cals paints in Dieppe and Pourville.

1866 *Aug 16* Returning from England, Flaubert spends a week

in Caude-Côte above Dieppe Château.

1867 *Aug 10* Flaubert is in Dieppe, and stays 2 days with his niece there in Sept.
Sept George Sand visits Saint-Valery-en Caux, Dieppe, Arques and Puys.

1868 Alexandre Dumas fils rents Maison Sellet at Puys after George Sand has praised the resort.
Aug Flaubert at 9 rue Albert Réville, Neuville.
Courbet visits Saint-Aubin-sur-Mer.

1870 *Jul 19* France declares war on Prussia.

LEFT
John Sell COTMAN
18. *Dieppe Harbour* 1823
watercolour on paper, 28.7 × 53.2 cm
The Board of Trustees of the Victoria and Albert Museum

Eugène ISABEY
Arrival of Queen Victoria at Tréport in 1843 (*Débarquement de la Reine Victoria au Tréport en 1843*)
oil, 30 × 45 cm
Château-Musée de Dieppe

Sep 2 Empire falls and the Third Republic is proclaimed.
Dec 5 Death of Alexandre Dumas père at Puys where his son has now built a house.
Dec 9 Germans occupy Dieppe.
1871 *Jan 29* Armistice. Flaubert in Dieppe in March and May. He is visited at Neuville by Turgenev.
Jun End of German occupation.
1874 Carpeaux stays with Dumas fils at Puys.

1875 Daubigny's son Karl paints the Vallée de la Scie.
1878 *early Oct* Oscar Wilde stays with the Sickerts.
1879 *Jul–Sep* Renoir stays with his patrons, the Bérards at their Château de Wargemont, near Graincourt, and does so each summer, apart from 1883, till 1885. Blanche becomes a pupil.
1880 Work starts on new Le Pollet channel to inner harbour. New docks are started.
Sickert becomes engaged to Ellen Cobden.

1881 A.P. Roll paints at Saint-Marguerite.
1882 Roll returns to Varengeville area most years up to 1887 and again in the 1890s.
Publication of the *Daily Express Tidal Service*, the first Continental Timetable between London and Paris.
Feb 5–6 Monet in Dieppe and at Pourville.
Jun 17 Monet's 2nd stay at Pourville.
Jul Impressionist dealer Paul Durand-Ruel in Dieppe: Blanche, still a student, later recalls meetings there with Monet, Renoir and Pissarro.
1883 At the artist's request, Sickert

takes Whistler's *Portrait of the Painter's Mother* to Paris to be shown in the Salon. Crosses via Dieppe, entertained by Wilde at the Hôtel du Quai Voltaire and calls on Degas.
Sep Renoir invited by Durand-Ruel in Dieppe to paint his 5 children.
1884 Wilde in Dieppe for part of his honeymoon.
autumn The Norwegian artist, Frits Thaulow, takes a house at Dieppe for the next 14 years.
1885 *summer* Returning from his honeymoon following his marriage to Ellen Cobden, Sickert takes a house at 21 rue de Sygogne, where Whistler

Punch cartoon, 7 September 1889

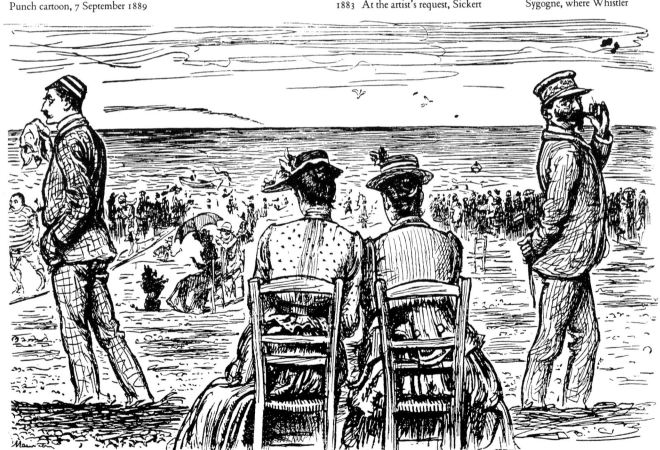

DIFFERENT FORMS OF SELF-CONSCIOUSNESS.

"Confound it! Those Girls were *laughing* as I went by! Wonder if I've got a *smut* on my Nose, or something!"
"Tiens! tiens! ces Demoiselles qui *rient* quand je passe! Évidemment elles trouvent que je ne suis pas trop mal!"
[*The Young Ladies are laughing at the antics of a Poodle in the middle distance.*]

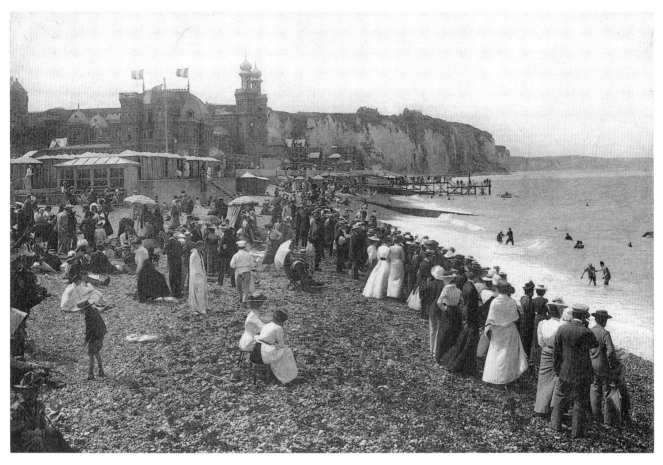

The Casino and Baths, Dieppe, at the turn of the century

comes to stay. Spends his summers in Dieppe for next 20 years. Helleu at Blanches' nearby house, Châlet Bas-Fort Blanc.

Aug 22 Degas stays with the Halévys at Villa Saint-James on the west end of the sea front, close to Blanche till Sep 12. He reports Whistler reading his 'Ten O'Clock' lecture to friends. In Blanche's studio he draws a group which includes Sickert, Blanche, Gervex, and Daniel and Elie, Ludovic Halévy's sons.

Oct 2 Gauguin writes that he has been in Dieppe for 3

months. He paints several pictures, on one of which Sickert comments adversely. He has also seen, and fallen out with, Degas.

Nov 3 Blanche marries Rose, daughter of the editor John Lemoinne.

1886 Thaulow marries his Russian second wife, a connection of Gauguin's by marriage. Boudin visits Dieppe.
Jul 11 Opening of new 'moorish style' casino.

1887 Comtesse Greffulhe's father-in-law buys her 'La Case', a large villa near the present golf course.

1888 Boudin in Dieppe.
Jul 24 Start of work on swing bridge between Dieppe and Le Pollet.

1889 Gabriel Fauré visits the Comtesse Greffulhe in Dieppe.
Apr 1 Newhaven-Dieppe service runs by timetable, independent of tides. Crossing time: 3 hours. Paris-London year-round night service, summer day service.

1890 Poet Arthur Symons in Dieppe.

1891 Blanche goes to Trouville to paint portrait of Marcel Proust.

1893 *Jun-Aug* Charles Conder spends two months painting at Vastérival. Stays at Hôtel Les Sapins, near Henry Harland, editor of the *Yellow Book*, who is in a villa with his wife, D.S. MacColl and others.

1894 Reynaldo Hahn meets Proust

at Madeline Lemaire's. Renoir's young friend Albert-André paints on the beach.

1895 *May 15* Alfred Douglas terms Dieppe 'a depressing place'.
summer Halévys are at the Villa Saint-James, Prince Poniatowski and the Duchesse de Carraciolo at Villa Olga, the Thaulows at Villa des Orchidées, which Conder now decorates for them. He meets Beerbohm, and remeets Dujardin, whom he once challenged to a duel. George Moore is at the Halévys.

The *Savoy*, successor to the *Yellow Book*, is largely planned on the tables outside the Café des Tribunaux by its editor, Symons, its art editor, Aubrey Beardsley, and its publisher Leonard Smithers. The poet

The Avant Port at the turn of the century

Ernest Dowson, a contributor, is also in Dieppe.
Aug 14 Conder, another *Savoy* contributor, writes from 2 rue de l'Oranger, where Symons too is lodging. In Aug-Sep Symons writes 10 Dieppe poems.
Aug 8–30 Reynaldo Hahn stays with Proust at 32 rue Aguado, Dieppe residence of Madeleine Lemaire.
late summer The diminutive artist William Rothenstein – in Dieppe to see Blanche who is painting Sickert's portrait – goes on tandem excursions with the blonde 'giantess', Frits Thaulow's wife, Alexandra.
Oct Conder leaves for Paris with recommendation from Thaulow to Bing of Art

Nouveau, for whom he paints silk panels.
1896 Albert-André paints in Dieppe, as does Boudin.
spring Conder in Dieppe.
Jun–Sep Symons writes 4 more Dieppe poems.
Sep Whistler in Dieppe.
1897 *Apr–Aug* Conder and Dowson are 'ruralising' in Arques at the Hôtel du Château.
May 20 On his release from Reading gaol Wilde comes to Dieppe. He is met by Reggie Turner and Robert Ross, to whom he gives his *De Profundis*. Six days later he moves to the Hôtel de la Plage, Berneval, under the name Sebastian Melmoth.
Jun 3 Wilde gives dinner to Dowson, Conder and

Dalhousie Young. On the 15th he breakfasts with Dowson at Arques; on the 19th they breakfast together at Martin-Eglise. June 16 Dowson takes Wilde to lunch and they return to Berneval for dinner.
Jun 7 Wilde writes to Rothenstein in England who hurries over to see him.
Jun 20 André Gide visits Wilde at Berneval.
summer Beardsley in Dieppe. Draws in a copy of *La Dame aux Camélias* given him by Dumas fils. 19 July he meets Wilde at a dinner party. Smithers visits Dieppe weekly until Beardsley's deteriorating health necessitates a September departure.
Jul Whistler and Conder in Dieppe. The latter then stays in Pourville, and, in October, at the Thaulows'.

Jul 18 Ceremonies in honour of Saint-Saëns, Dieppois by ancestry and choice.
Sep 25 Wilde leaves for Paris.
1898 Edwin Lutyens completes 'Le Bois des Moutiers', his first great private house, for the Mallet family at Varengeville. Maurice Maeterlinck and the Rouen-born actress Georgette Leblanc rent the old presbytery at Gruchet near Luneray as summer residence till 1905.
Mar 16 Death of Beardsley at Menton.
Feb Conder is with the Hacons at their flat 38 rue Aguado
May The Renoirs rent Wilde's chalet at Berneval.
end May Conder leaves Dieppe.
1899 Ellen Cobden divorces Sickert for adultery with the Le Pollet fishperson Augustine Villain at a Newhaven hotel. From then till 1905 he lives mainly in

A. Bettembos éditeur Dieppe

1900 *Feb 23* Death of Dowson, burial in Lewisham.
summer Pissarro at Berneval.
Jul 11 Reopening of the Dieppe theatre after refurbishment.
Oct 8 Start of demolition of the Hôtel Royal.
Nov 30 Death of Oscar Wilde in Paris.
1901 *summer* Pissarro in Dieppe.
Jul Whistler in Dieppe.
Jul 17 The new Hôtel Royal is opened.
Jul 31 Beerbohm writes from Lefèvre's and again 5 Sep.
1902 Sickert paints four panels for a Dieppe café.
Pissarro spends another summer in Dieppe.
1903 The Swiss Nabi Vallotton paints 17 pictures at Arques.
Jul 17 Death of Whistler.
Aug 27 A new ship, the turbine-engined *Brighton*, makes maiden crossing in 3 hrs 3 mins.
Sep Max Beerbohm in Dieppe with Constance Collier, to whom he becomes engaged in December.
Nov 13 Death of Pissarro.

1904 Albert Rutherston brings Spencer Gore to see Sickert in Dieppe. Debussy composes 'L'Isle joyeuse' there. Sickert Paris exhibition chez Bernheim Jeune.
summer Vallotton and his wife stay at Varengeville, where he paints landscape sketches. He has invited Bonnard, who prefers to lodge in Dieppe with Marthe, his future wife.
Jul 15–Oct 15 Pierre Monteux, viola player with the Colonne Orchestra, is an assistant conductor at the Casino. He was later conductor until 1914.
Aug Beerbohm, in Dieppe following his broken engagement, celebrates his birthday on 24th.
mid Sep Casino Orchestra plays. 'A Brighton March' by Trespaillé and Gabriel-Marie's 'Dieppe March' in Brighton.
1905 Percy Grainger comes to Dieppe 2–3 times in next two years. He is the first 'English' (actually Australian) pianist to include Debussy and Ravel in programmes. Beerbohm too is in Dieppe.

Neuville-lès-Dieppe. His studio is on the Tour aux Crabes.
summer William Rothenstein on honeymoon is booked into Titine Lefèvre's by Sickert. He goes to Vattetot, the scene of a later summer visit where he is joined by his brother Albert Rutherston, Conder, Augustus John and Orpen. After which Conder stays at Villa Helmont, Pourville.
Jul Lady Blanche Hozier arrives in Dieppe with her children. They spend that summer at Puys.
Sep 27 Camille Pissarro on summer visit to Varengeville.
Jul-Oct Whistler at Pavillon Madeleine, Pourville.

Ben Nicholson in Dieppe, 1903

Mar 5 Completion of Debussy's 'La Mer'. He stays at Eastbourne that spring.
mid Jun At Gruchet Maeterlinck writes *The Blue Bird*.
Jul 14 J.D. Fergusson paints the Dieppe firework show. Eventually he settles there.

1906 The German-American Lyonel Feininger, then a comic draughtsman for the *Chicago Tribune*, stays at Quiberville and Ouville-la-Rivière some 5 miles west of Dieppe. The Gore family rent Sickert's Neuville house for the summer.
Jul–early Aug Raoul Dufy and Albert Marquet in Dieppe.
Aug Debussy at Puys.

1907 Harold Gilman rents Sickert's house at Neuville.

1908 Following the Allied Artists' Association show at the Albert Hall, Frank Rutter writes that 'most of us had spent that August and September in Dieppe.' Henri Matisse, too, visits Dieppe, on June 6.

1910 Edwin and Emily Lutyens visit Varengeville where he is building a second house for the Theosophists. M. and Mme Mallet. Emily is introduced to Theosophy and the work of Annie Besant, now president of the Theosophical Society and a coming leader of the Indian National Congress. In May she joins the Society. Sickert leaves Neuville for the Villa d'Aumale, Envermeu. Moves again later to the Maison Mouton on the fringe of Envermeu. He paints Blanche's portrait.

1911 Sickert remarries. Ginner visits Dieppe, as does Gilman. They paint *The Sunlit Quay* and *The Swing Bridge* respectively. The second of these is the Camden Town Group's wedding present to the Sickerts, who spend their honeymoon in Dieppe.

1912 Blanche paints the young Cocteau's portrait at Offranville. Sickert is now at Envermeu until 1913.

Dieppe, 1927, photograph by A. Kertész
Cliché Musée National d'Art Moderne, Paris

Dieppe, 1931, photograph by A. Kertész
Cliché Musée National d'Art Moderne, Paris

Apr 24–5 The *Paris* makes a crossing in 2 hrs 35 mins.

1913 Chance meeting between Sickert and Wyndham Lewis at Envermeu. Ginner and William Ratcliffe both painting in Dieppe.

1914 Outbreak of World War I.

1915 Debussy at 'Mon Coin', Pourville. He finishes his cello sonata and composes his *Twelve Studies* and *En blanc et noir*. Mata Hari sails from Dieppe to Folkestone, where she is arrested.

1918 Armistice ends the war.

1919 The Sickerts buy the Maison Mouton at Envermeu and remain in the area.

1920 Robert Lotiron paints in Dieppe.
Oct Death of Christine Sickert.

1921 Lotiron returns to Dieppe. Sickert paints his series of 'baccarat' pictures in the Casino.

1922 Albert Roussel buys a house at Vastérival. Towards the end of the year Sickert returns to London, never to live in Dieppe again.

1923 Sickert spends a few weeks in Dieppe, clearing up his affairs.

1926 Matthew Smith visits Dieppe. Sickert marries Thérèse Lessore, a fellow-painter.

1927 *summer* Braque visits Dieppe. *Jul/Sep* Duncan Grant and Vanessa Bell pay two visits to Auppegard to paint murals in a loggia for Ethel Sands and Nan Hudson, friends of Blanche and former pupils of the Camden Town school.

1928 Vita Sackville-West and Virginia Woolf stay at Auppegard.

1929 Christopher Wood paints in Dieppe. Georges Braque paints beach scenes.

1930 Othon Friesz paints in Dieppe and Varengeville.

1931 Friesz is again in Dieppe. Braque has built a house and studio at Varengeville. William Coldstream in Dieppe.

1932 Lotiron again in Dieppe. *August* Ben Nicholson and Barbara Hepworth in Dieppe.

1933 Nicholson and Hepworth visit Braque in Varengeville.

1935 Sickert makes sentimental last journey to Dieppe for the funeral of Augustine Villain.

1937 Miró, Braque, Léger and

Barbara Hepworth in Dieppe, 1932

Calder in Varengeville; Calder invites Nicholsons and Pipers to stay.

1939 *Sep* Gwen John, on arrival from Paris, collapses and is taken to the Hôpital Civil.

Outbreak of World War II. *Sep 18* Gwen John dies and is buried in the Fosse Communale at Janval under the name of Mary Jhon.

DIEPPE AND ITS ENVIRONS

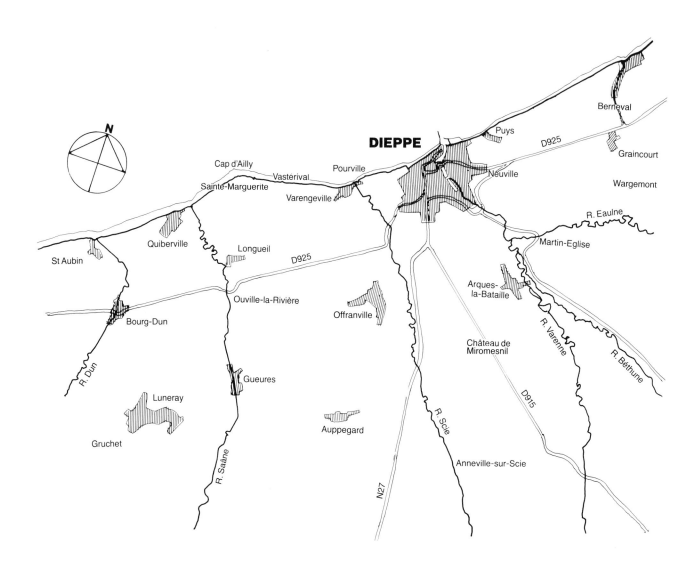

N

Berneval

Puys

D 925

Graincourt

DIEPPE

Wargemont

Cap d'Ailly

Vasterival

Pourville

Neuville

Sainte-Marguerite

Varengeville

R. Eaulne

Martin-Eglise

Quiberville

Longueil

D 925

St Aubin

Arques-
la-Bataille

Ouville-la-Rivière

Offranville

R. Varenne

R. Béthune

Bourg-Dun

Château de
Miromesnil

R. Dun

Gueures

D 915

Luneray

Auppegard

Gruchet

R. Scie

Anneville-sur-Scie

R. Saâne

N27

0 1 5 10 kilometres

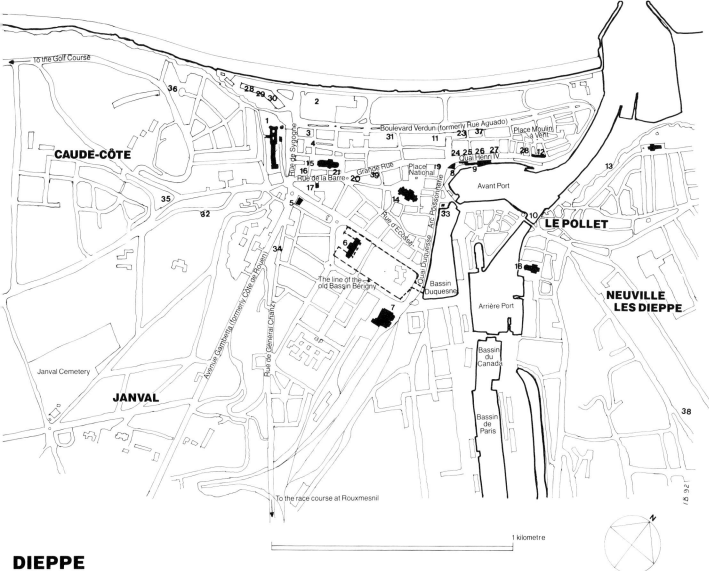

DIEPPE

1 The Château
2 Sites of the old Casinos
 1824 (Duchesse de Berry)
 1857 – 1886 – 1928
3 The Theatre
4 Place Camille St Saëns
5 The Law Courts
6 The Mairie (built after World War II)
7 The Station
8 The Fish Market
9 Gare Maritime
10 The swing bridge
11 The site of the old Tobacco factory
12 Tour aux Crabes
13 Les gobes (caves)
33 The old Customs House
39 Au Chat Botté

CHURCHES

14 St Jacques
15 St Rémy
16 2nd Anglican church
17 All Saints
18 Notre Dame des Grèves

VILLAS

28 Châlet Bas-Fort Blanc
29 Villa Olga
30 Villa St James
32 Villa les Orchidées, 21 rue des
 Fontaines (Frits Thaulow)
34 Villa Grazielle (Maundy Gregory)
35 Villa of Revd Merk
36 Villa la Case (Comtesse Greffulhe)
37 Villa 44 rue Aguado [now Verdun]
 (Sickert after 1914)

38 Villa 9 rue Albert-Réville
 (Flaubert's niece)

CAFES

19 Suisse
20 Tribunaux
21 Sole Dieppoise

HOTELS (before 1900)

23 Etrangers
24 de L'Europe
25 de Londres
26 Prince Régent
27 Nord et Victoria
28 d'Angleterre
31 Royal

Further Reading

The literature on Dieppe is vast and scattered, and it is not possible in this catalogue to do it justice. Books about the following key figures are recommended:

Artists: Turner, Bonington, Cotman, Corot, Isabey, Delacroix, Ruskin, Courbet, Boudin, Monet, Pissarro, Degas, Renoir, Gauguin, Whistler, Blanche, Sickert, Thaulow, Conder, Beardsley, Orpen, William Nicholson, The Camden Town Group, The Scottish Colourists, Matthew Smith, Christopher Wood, Ethel Sands, Braque, Miró.

Composers, Writers and Notables: Flaubert, George Sand, Proust, Dowson, Wilde, Beerbohm, Arthur Symons, Saint-Saëns, Debussy, Fauré, Maeterlinck, Lutyens, Gide, Cocteau, Roger Fry, William Rothenstein, The Bloomsbury Group.

Books by Wendy Baron, Lilian Browse and Frances Spalding, all with detailed bibliographies, are particularly helpful. The following publications concentrate on Dieppe, its landscape and history.

AVIS, PETER, (ed.) *A Taste of Dieppe*, annual publication, Ville de Dieppe.

BAZIN, PIERRE, *Dieppe et les peintres*, Dieppe 1984.

BLANCHE, JACQUES-EMILE, *Dieppe* (dedicated to Sickert), Emile-Paul Frères, Paris 1927.

—— *Portraits of a Lifetime 1870–1914*, Dent, London 1937.

—— *More Portraits of a Lifetime 1918–1938*, Dent, London 1939.

BOUDIER, ANDRÉ & FÉRON, CLAUDE, *Dieppe et ses environs*, Boitel, Dieppe 1959.

DAVID, MARIUS, *Dieppe et ses environs*, Dieppe 1983.

DESHOULIÈRES, F., *Dieppe*, Henri Laurens, Paris 1929.

DE TOURS, CONSTANT, *Sur les Côtes de la Manche*, Bastion n.d.

DUTEUTRE, MAURICE, *Dieppe à la Belle Epoque*, Editions Libro-Sciences, Brussels 1974.

FÉRON, CLAUDE, *Dieppe*, Editions Latines, Paris n.d.

—— *Dieppe 1885–1920*, La Vigie, Dieppe 1984.

—— *Les rues de Dieppe*, Informations Dieppoises 1975.

FÉRON, CLAUDE (Editor), *Connaissance de Dieppe et sa région*, a remarkable monthly magazine of all aspects of local history, in its eighth year of publication. Editions Bertout, Luneray.

GAUNT, WILLIAM, *The Aesthetic Adventure*, Cape, London 1975.

Guide Bleu – Normandie, Hachette 1985.

GUNN, PETER, *Normandy, Landscape with Figures*, Gollancz, London 1975.

LEPROHON, PIERRE, *Les Peintres de la Côte Normande*, Corymbe, Antony 1982.

Les Amys du Vieux Dieppe, annual bulletins of the local history association founded in 1912. Imprimerie Dieppoise.

Les Informations Dieppoises and *Paris-Normandie*; these two newspapers both have extensive material.

LYMBERY, ETRENNE, *An introduction to Dieppe*, Crampton-Moorhouse, London 1983.

MERK, The Revd CHARLES, *A History of Dieppe*, Paris 1909

MÜLLER, VALÉRY, *Impressions Dieppoises*, Imprimerie Dieppoise 1911.

PAKENHAM, SIMONA, *Sixty Miles from England, The English at Dieppe 1814–1914*, Macmillan, London 1967. Also published in French: *Quand Dieppe était Anglais*, Informations Dieppoises, 1970.

—— *Pigtails and Pernod*, Macmillan, London 1961.

SOAMES, MARY, *Clementine Churchill*, Cassell, London 1979.

TAILLANDRE, ISABELLE, *La Villégiature à Dieppe sous la Restauration*, un pratique artistocratique. Bertout, Luneray 1990.

Lenders

Aberdeen City Art Gallery and Museums Collection (56) (91) (92)

Bevan, Natalie (30)

University of Birmingham, The Barber Institute of Fine Arts (49)

Birmingham Museum and Art Gallery (17) (62) (63) (80)

Brighton, The Royal Pavilion, Art Gallery and Museums (41) (83)

Cambridge, The Syndics of the Fitzwilliam Museum (14)

Cherniavsky, Mark (7)

Dieppe, Château-Musée de Dieppe (9) (44) (70)

Edinburgh, National Galleries of Scotland (21)

Eric Estorick Family Collection (48)

University of Glasgow, Hunterian Art Gallery, Birnie Philip Bequest (88)

Glasgow, The Burrell Collection, Glasgow Museums (77)

Hull City Museums and Art Galleries, Ferens Art Gallery (68)

University of Hull Art Collection (46)

Collection M. & Mme C. Laurens (13)

Leeds City Art Galleries (25)

Liverpool, National Museums and Galleries on Merseyside (Walker Art Gallery) (28) (75)

London, Arts Council Collection, The South Bank Centre (50)

London, The British Library Board (89)

London, Guildhall Art Gallery, Corporation of London (81)

London, Noortman (London) Ltd (19)

London, Michael Parkin Gallery (34) (35) (36) (42) (57) (82)

London, Save and Prosper Group Ltd (27)

London, The Trustees of the National Gallery (40)

London, The National Portrait Gallery (4) (6) (60)

London, The Trustees of the Tate Gallery (51) (66) (71) (79)

London, The Board of Trustees of the Victoria and Albert Museum (1) (18)

Peter and Katharine Makower (65)

Manchester City Art Galleries (10) (15) (23)

(45) (74) (90)

University of Manchester, Whitworth Art Gallery (72)

Nantes, Musée des Beaux-Arts (47)

Oxford, The Visitors of the Ashmolean Museum (2) (3) (24)

Paris, Musée National d'Art Moderne, Centre Georges Pompidou (22) (39)

Paris, Musée d'Orsay (54) (58) (59) (64)

Paris, Musée de l'Orangerie des Tuileries (61)

Paris, Musée du Louvre, Département des Peintures (20)

Philadelphia Museum of Art, Bequest of Lisa Norris Elkins (55)

Rouen, Musée des Beaux-Arts (5) (8) (38) (43) (69)

Sheffield City Art Galleries (16) (29) (37) (67)

Stockholm, Moderna Museet (12)

Windsor, The Provost and Fellows of Eton College (84)

Private Collections (11) (26) (31) (32) (33) (52) (53) (73) (76) (78) (85) (86) (87)

Acknowledgements

Many people have helped in the preparation of this exhibition. We would particularly like to thank:

Pam Aldridge
David Alston
Ian Baker
Michael Barker
Pierre Bazin
François Bergot
John Bernasconi
Natalie Bevan
Alan Bowness
Fiona Brown
Ann Bukantas
Françoise Cachin
Richard Calvocoressi
Sarah Carthew
Mark Cherniavsky
John Chippindale
Bettie Clark
Louisa Connor
Jill Constantine
Shirley Corke
Henri-Claude Cousseau
Lewis & Louisa Creed

William Darby
Amanda Jane Doran
Marina Ducrey
Eric Estorick
Claude Féron
Christopher Gilbert
Frederick Gore
Lena Granath
Anna Gruetzner Robins
Vivien Hamilton
Anne d'Harnoncourt
Rupert Hart-Davis
John Hayes
Tim Henbrey
Gavin Henderson
Alexander Hidalgo
Derek Hill
Michel Hoog
Martin Hopkinson
Lianne Jarrett
Simon Jervis
Isobel Johnstone

Shelley Jones
Andras Kalman
Louise Karlsen
Michael Kitson
Vivien Knight
Geneviève Lacambre
Bill Laidlaw
Sue Lambert
Jean Lapeyre
Monsieur & Madame Laurens
Etrenne Lymbery
Neil MacGregor
Malcolm McLeod
David McNeff
Gilles Mahé
Peter & Katharine Makower
Cathérine Marcangeli
Laure de Margerie
Lynn Marlow
Sandra Martin
Catherine Mathieu
Peter Mock

Tim Moreton
Sarah Morris
Andrew & Tim Nicholson
Michael Parkin
John Patterson
Joachim Pissarro
Andrew Prescott
Nancy S. Quaile
Catherine Regnault
Joseph Rishel
Alex Robertson
Pierre Rosenberg
Béatrice Schiltz
Manuel Schmit
Didier Schulmann
David Scrase
Nicholas Serota
Joseph Sharples
John Shelley
Janet Skidmore
Peyton Skipwith
Elizabeth Smallwood

Alistair Smith
Julian Spalding
Paul Spencer-Longhurst
Bjorn Springfeldt
Chris Steel
Mary Ann Stevens
Christine Stokes
Clare Taylor
Elise Taylor
J.S. Taylor
Belinda & Richard Thomson
Julian Tomlin
Julian Treuherz
Paul Tritton
Philip Vainker
Angela Verren-Taunt
Jeff Watson
John Whately
Ann Wheeler
Catherine Whistler
Stephen Wildman
Anne Willett

SB, CC, JW